Gustav

The White
Dominican

**Translated from the German by Mike Mitchell,
and with an introduction by John Clute**

DEDALUS/ARIADNE

Dedalus would like to thank The Austrian Ministry of Culture & Education in Vienna for its assistance in producing this translation.

Published in the UK by Dedalus Ltd,
Langford Lodge, St Judith's Lane, Sawtry, Cambs, PE17 5XE

UK ISBN 1 873982 55 0

Published in the USA by Ariadne Press,
270 Goins Court, Riverside, California, 92507

US ISBN 0 929497 88 0

Distributed in Canada by Marginal Distribution,
Unit 103, 277 George Street North, Peterborough, Ontario, KJ9 3G9
Distributed in Australia and New Zealand by Peribo Pty Ltd,
26 Tepko Road, Terrey Hills, N.S.W. 2084

Distributed in South Africa by William Waterman Publications,
PO Box 5091, Rivonia, 2128

First published in Germany in 1921
First English translation 1994

Translation and Introduction copyright © Dedalus 1994

Printed in Finland by Wsoy
Typeset by Cygnus Media Services, Llangadog, Wales, UK

DEDALUS EUROPE 1992–95

supported by
The Austrian Ministry
of Culture & Education

Dedalus as part of its Europe 1992–95 programme is combining with Ariadne Press to make all of Gustav Meyrink's novels available in English in new translations by Mike Mitchell.

Titles so far published:

The Angel of the West Window
The Green Face
Walpurgisnacht
The White Dominican

forthcoming:

The Golem (1995)

In addition a selection of Gustav Meyrink's short stories translated by Maurice Raraty *The Opal (and other stories)* has been published in 1994.

Extracts from all of Meyrink's five novels and some of his short stories have been included in *The Dedalus/Ariadne Book of Austrian Fantasy: the Meyrink Years 1890–1930*.

THE TRANSLATOR

Mike Mitchell is a lecturer in German at Stirling University. His publications include a book on Peter Hacks, the East German playwright, and numerous studies on aspects of modern Austrian Literature; he is the co-author of *Harrap's German Grammar* and the editor of *The Dedalus Book of Austrian Fantasy: the Meyrink Years 1890–1930*.

Mike Mitchell's translations include *The Architect of Ruins* by Herbert Rosendorfer, *The Works of Solitude* by Gyorgy Sebestyen, and Gustav Meyrink's novels *The Angel of the West Window*, *The Green Face*, *Walpurgisnacht* and *The White Dominican*.

He is currently engaged on translating Gustav Meyrink's *The Golem* into English.

INTRODUCTION

Gustav Meyrink, it is possible to think, lived a life that was more like a dream than any of the stories he wrote. He was a bastard, a banker, an inventor, a fin-de-siècle flaneur, a jailbird, a guru who flyted his disciples, a pacifist in love with apocalypse, a magus who condemned the halitosic prattle of occultism. Each stage of his life had the saturated gluey intensity of dream; and the life as a whole seemed spatchcocked out of legend and sleep, a congeries of psychopomp blurbs. He was an Arcimboldi Green Man: rags and patches of life-stuff; granny-knots of circumstance unravelling at a jerk as the century downturned into disaster; a foliate head. The stories he wrote seemed to exfoliate from the life.

He was born Gustav Meyer, in Vienna. His mother was an actress and his father an elderly aristocrat with a position in government. Grotesquely maladroit parent-figures appear and reappear throughout the fiction, most notably perhaps as the crone-courtesan and floundering ectomorph nobleman whose ultimate reconciliation transfigures his third novel, *Walpurgisnacht* (1917; translated by Mike Mitchell for Dedalus in 1993).

He moved to Prague as a young man and became a banker, an athlete, a philanderer, a fencer, and the owner of that city's first automobile. Much of the carnival night life hinted at in *Walpurgisnacht*, and treated in detail throughout his second novel, *Das grune Gesicht* (1916; translated by Mike Mitchell for Dedalus in 1992 as *The Green Face*), seems to make nineteenth century Prague visible in a crazy mirror, as topsy-turvy as the new century boded to become.

His first marriage ended badly. He remarried under circumstances which seemed scandalous to the Prague world he mocked, and which occasioned vicious gossip. He challenged one of his new wife's slanderers to a duel, but the challenge was declined on the grounds that, as a bastard, he was inherently incapable of receiving satisfaction. At about the same time, in 1902, he was arrested and imprisoned for three months, on

charges of fraud. He was exonerated, but on his release was discovered to have tuberculosis of the spine. He was also destitute. His life as a banker Harlequin had terminated as though he had walked a plank, into a new medium. His first novel, *Der Golem* (1915; translated by Madge Pemberton in 1928 as *The Golem*; a new translation by Mike Mitchell will appear from Dedalus in the spring of 1995), is structured around visions of unbearable parents, occult amnesia, the false polder of the soon-to-be-demolished ghetto, a supernatural doppelganger who evokes a lacerating sehnsucht in the blanked protagonist, surreal interrogations and false imprisonment in a Prague like Kafka's, and an invisible new life told through a frame story which opens opaque hints of that new life whose details the novel cannot presume to depict.

But before Gustav Meyer's first life ended, he had begun the life for which he is now remembered. His first story, which was written under the name Meyrink, appeared in the magazine *Simplicissimus* in 1901, and within a few years he had become a central figure in pre-War German literature, a literature whose proleptic convulsiveness and *rightness* about the world to come it is difficult now, nearly a hundred years on, to comprehend. In 1994 it is difficult, and humbling, to realize that they were saying as much as we can about the heartbeat of the century; it is at times almost impossible not to feel that the apocalyptic insights we detect are simply, in fact, endogenous fevers of Expressionism: that we are patching 1910 metaphors into our knowledge of subsequent history, shaving them to fit. This indeed must surely happen: it must surely be the case that we do read them selectively, and that the writers and artists and composers and scholars and thinkers and architects of 1910 *could not know* that they were right, that the clock of history (as they intimated) had begun to stutter, setting off all the alarms at once. In the end, however, it may not altogether matter if they knew they were right. In the end, perhaps, it is more important for us to realize that – in their dreams and paranoias and dread – they saw us here.

For English readers, it is not yet possible to know how fully Meyrink's earliest fiction engaged with the first years of turmoil, as he only began publishing his novels after World War One had already started. His initial reputation on the Continent came from the large number of short stories he published before *The Golem* first appeared, and which were collected in several volumes: *Der heisse Soldat und andere Geschichten* ["The Hot Soldier and Other Stories"] (1903); *Orchideen: Sonderbare Geschichten* ["Orchids: Strange Stories"] (1904); *Das Wachsfigurenkabinett: Sonderbare Geschichten* ["The Wax Museum: Strange Stories"] (1907); *Des deutschen Spiessers Wunderhorn* ["The German Philistine's Magic Horn"] (1913), the last being a three-volume omnibus incorporating old and new material; and *Fledermase* ["Bats"] (1916). E F Bleiler's *Guide to Supernatural Fiction* (1983) lists only one short story by Meyrink in English. *The Golden Bomb: Phantastic German Expressionist Stories* (1993) ed Malcolm Green includes a different one; and *The Dedalus/Ariadne Book of Austrian Fantasy: The Meyrink Years, 1890-1930* (1992) ed Mike Mitchell includes five: which is a significant start, but one which shows the largeness of the vista that can be further unveiled now with *The Opal (and other stories)* collection of Meyrink stories translated by Maurice Raraty (Dedalus 1994).

On the whole, we are left with a fever of belatedness, through which the past makes the present (and the future) dance to dead tunes. *The Golem* is meant to be taking place around 1890, but scumbles chronology so thoroughly that the reader will find it hard to avoid conflating the destruction of the ghetto with larger devastations, or the mephitic arousals of psyche emblematized by the golem itself with more widespread (and far more vicious) hysterias. *The Green Face*, which was being drafted as World War One began, is ostensibly set in the future, after the end of hostilities, but the outcome and aftermath of the war are viewed, by an act of occultish legerdemain, through the lens of an ashen retrospect: the labyrinth of the trenches, like some rebirthing of Cthulhu; the end-of-the-world perspectives gran-

ted by No Man's Land; the taste of a world-order exhausted, of the dithering puniness of secular man sifting the ruins for loot. It is astonishing that the book reached publication in the midst of a total war which was being lost. Like *Walpurgisnacht*, which also appeared before 1918, but far more explicitly, *The Green Face* treats the War to End War as a Saturnalia, a *danse macabre* which ends in Wind: in an apocalyptic harrowing of Europe, obliterating the false face of the material world.

Beneath that face (it is a turn of vision fundamental to occult dualism, and it appears in all Meyrink's work) can be discerned a higher, spiritual world of true effect and cause, which can now be celebrated in a chymical marriage between the scoured protagonist (all his protagonists have been deeply wounded by the harlequinade of appearance) and his dead love (Meyrink females, if they are worthy, are almost certain to be dead).

It may all come down to his actress mother, who abandoned him in early childhood; but it may, as well, have something to do with the fancy-step metamorphosizing almost any European writer of Meyrink's period engaged in whenever the Female Principle was to be distinguished from the Female Body. Whatever the cause, it cannot be denied that throughout his career Meyrink's female characters, with the exception of an occasional nurturing crone from the lower orders, occupy only two categories: either they are avatars of Medusa, whose wormy sexuality turns men into stone, imprisoning them in the maya of existence; or they are Beatrice and – having died well before the end of the novel – await their husband-to-be's union with them in a higher world. Modern readers (of whom half may be presumed to be women) may understandably find this aspect of the male dualist imagination both distasteful and inutile; but it is an inescapable component of Meyrink's worldview from beginning to end.

In each of the first three novels, a transfiguring chymical marriage climaxes the personal story, though in each of these books the jettisoning of the material world is achieved with a panoramic glitter. After the end of World War One, however,

Meyrink discarded the contemporary world, and his late work radically disengages from that Europe of aftermath he had so prophetically limned; there are no more prophetic spasms to remind us now, at the end of the millennium, that our visions of doom are epigonic. At the same time, however, he did continue to adhere to the occult dualisms to which (like William Butler Yeats) he seemed to give credence, and which shaped and fortified his work, though at the same time he never lost his marbles: whenever he was confronted with fraudulence or Golden Dawn vaporizings, he proved to be a savage debunker. But dualism in the hands of any male European writer born in the last century is almost invariably fatal to the female of the species, and it does remain the case that the modern reader may have trouble with some of the more didactic passages of his fourth novel, *Der weisse Dominikaner* (1921), now translated for Dedalus as *The White Dominican* by Mike Mitchell, in a style which admirably captures Meyrink's sly swift eloquence. There can be no doubt whatsoever that the ongoing Medusa/ Beatrice dualism – even when it is toned down by the fact that the only whorish female in the book is far too old to entrap the protagonist – will be hard for most contemporary readers to swallow. What remains?

In the event, a great deal. What *The White Dominican* loses in being the first fruit of Meyrink's chastened post-catastrophe imagination, it gains in supernal equipoise, in an oneiric serenity which tugs very hard at the roots in dream of our own responses to the allure of Story. We begin with a frame: the author of the tale, who seems to be Meyrink himself, tells the reader that he has never found out for sure whether or not the protagonist of the story "ever actually lived; he certainly did not spring from my imagination, of that I remain convinced." This protagonist, it turns out, has mysteriously caused Meyrink to call him by his proper, heavily symbolic name, Christopher Dovecote, a name Meyrink claims to be unconscious of having used when drafting his novel; and we are cast immediately into a Tale whose material embodiment (the words we read, the

paper we touch) is itself a lesson imparted. To understand the Tale we must understand that the words we read are nothing but echoes, caught in the Medusa dust of corporeality. "Being born on earth is nothing other than being buried alive." The true Tale will be what we rise to learn.

We enter the main story, which is told in the first person by Dovecote himself. He is an orphan, abandoned as an infant on the steps of the local church, but soon is adopted by the dominant figure in the town, Baron Bartholomew von Jöcher, Freeman and Honorary Lamplighter. The town itself is never named. It lies downstream from the capital of the country, which is not named either. Only Paris – which is also the name of the fraudulent impresario who is the real father of the Beatrice figure we are soon to meet – can be recognized as a place inhabiting mortal history. The river comes north from the capital, almost completely encircles the town, and departs southward; on the neck of land separating the river flowing north and the river flowing south is the Baron's house, which has been occupied by his family for something like thirteen generations. Each new generation of von Jöchers abandons the floor occupied by its predecessor, and moves upwards within the house, which must therefore, like so many labyrinth-portals to other worlds, be bigger inside than out. The town itself – empoldered by the river and guarded by the house whose occupants are themselves Guardians of (and Aspirants to) the Threshold to the upper levels – seems utterly secure.

Within this polder, at the top of this ladder of generations of Guardians, Christopher grows up. He finds he is the Baron's true son. He falls in love with the girl who lives in the house next to his. Her name is Ophelia. She too has difficulties in relating her nature to her corporeal parentage: her ostensible father, the town's coffin-maker and a man mentally damaged from the time his own father buried him alive in a coffin as a punishment, is not her father at all. Her true father, the reprehensible impresario Paris with his camp aristocratic mien, and her mother, the failed whorish actress, connive in repression and bad faith.

But she transcends her corporeal bondage, she returns Christopher's love, and – as any reader experienced in Meyrink will know from the fact of that love for the protagonist, and from her name – she soon dies, voluntarily. But by then Christopher has undergone night journeys into occult realms; he has been told that he is destined to become transfigured, to rise from the top of the Tree of the Lamplighter family into true reality; and he treats her death as a confirmation of betrothal.

To this point, in *The White Dominican*, we have been gifted with scenes of epiphanic calm which alternate with "real-world" episodes of Dickensian splendour (Meyrink translated Dickens earlier in his career) whenever the lovable, duped coffin-maker comes into view. From this point onwards, in passages that shift levels of import as do dreams, we are invited to follow Christopher into his inheritance. Some of the terms of that invitation are couched with a didactic precision some readers may find distressingly liturgical, because Christopher's ascension is that of a magus, cloaked in arcana; but the flow of the ascent is irresistible.

And the visitations of the Medusa, the corporeal world, in false likenesses of the dead Ophelia, have a power that easily transcends the doctrinaire sexual Manicheeanism through which Meyrink articulates his vision of "the impersonal force of all evil, using the mute forces of nature to conjure up miracles which in reality are only hellish phantasms serving the ends of the spirit of negation." But "the head of Medusa, that symbol of the petrifying force that sucks us down," has no final sway, and the chymical marriage will ultimately be consummated, in some realm the pages of the book cannot reach. So be it.

We may baulk at some of the terms in which it is put. But it is his final word. After this novel came only the alchemical tales published as *Goldmachergeschichten* ["Tales of the Alchemists"] (1925) and the intermittently brilliant *Der Engel Vom Westlichen Fenster* (1927); translated by Mike Mitchell for Dedalus in 1991 as *The Angel of the West Window*], about Doctor Dee; neither book coins a new metaphor to replace the

11

Medusa. It seems clear that for the Meyrink of the post-War years, the image of the Medusa was definitive. The Medusa, it is possible to think, was nothing less than the entirety of the world which opened its maw to sensitive men and women in 1914. The Medusa, whose image he unforgettably presented to his readers, stares upon us through every newsreel the century has disgorged. It is the tetanus which fixes us upon the wheel of time. It is surely not Gustav Meyrink's fault that, for most of us, there will be no chymical marriage.

John Clute

The White
Dominican

GUSTAV MEYRINK
THE WHITE DOMINICAN

From the Diary of an Invisible Man

Preface

"X or Y has written a novel." What does that mean?

It is quite simple: he has used his imagination to portray people who do not really exist, has invented experiences for them and woven it all together. In broad terms that, or something like it, is the general opinion.

Everyone assumes they know what imagination is, but there are very few who are aware of the remarkable forms of imaginative power that exist.

What is one to say when one's hand, usually such a willing tool of the mind, suddenly refuses to write the name of the hero of the story one has thought up, and insists on choosing a different one instead? Is it not enough to make one pause and ask oneself, "Am I really the one who is 'creating' this work, or is my imagination merely some kind of receiver for supernatural communications? Something like what is called, in the sphere of wireless telegraphy, an aerial?"

There have been cases of people getting up in their sleep at night and completing pieces of writing, which, tired from the day's toil, they had left unfinished, and finding better solutions than they would probably have been capable of when awake. People tend to explain such things by saying it was done by their subconscious, which is usually asleep.

If something like that happens in Lourdes, they say the Mother of God came to their aid.

Who knows, perhaps the subconscious and the Mother of God are the same thing?

Which is not to say that the Mother of God is simply the subconscious, no, the subconscious is the 'mother' of 'god'.

15

In the present novel a certain Christopher Dovecote plays the role of a living person. I never succeeded in finding out whether he ever actually lived; he certainly did not spring from my imagination, of that I remain convinced. I say that openly, even if there is a danger people will think I am only saying it for effect.

This is not the place for a detailed description of the way this book came to be written, a brief sketch of what happened will suffice. In order to give that, it is unavoidable that I should talk about myself, which I will do in a few sentences, for which I hope the reader will forgive me.

I had worked out the whole of the novel in my head and started writing it down when I noticed – but only when I read through my draft – that I had written the name 'Dovecote' without being aware of it. But that was not all. As the pen moved across the paper, whole sentences changed and came to express something completely different from what I had intended. It developed into a duel between myself and the invisible 'Christopher Dovecote' in which he ultimately gained the upper hand.

It had been my plan to portray a small town that lives in my memory; what emerged was a completely different picture, a picture that is much more vivid to my mind's eye than the one I had actually seen. Eventually there was nothing for it but to give in to the influence that called itself Christopher Dovecote, to lend him my hand, so to speak, to write down his story and to cross out everything that came from my own ideas.

If we assume this Christopher Dovecote is an invisible being who in some mysterious way is able to impress his will on a person of sound mind, then the question arises, why is he using me to describe his life-story and the process of his spiritual development?

Is it from vanity? Or to create a 'novel'?

I leave it to each reader to reach his own conclusion and keep my own opinion to myself.

Perhaps soon my case will not be an isolated one; perhaps this 'Christopher Dovecote' will guide someone else's hand

tomorrow.

Something that appears unusual today might be an everyday event tomorrow.

Perhaps it is that ancient, yet ever-new insight which is beginning to manifest itself:

> Each single action here on earth
> Accords with nature's rule;
> "I am the author of this act" –
> Thus speaks the self-deceiving fool.

and the figure of Christopher Dovecote is only a harbinger, a symbol, the visible form assumed by an intangible force?

Of course, the idea that man is a mere puppet on a string is anathema to the know-alls who are so proud to think of themselves as lords of creation.

One day as I was writing, with these ideas running through my mind, I suddenly thought, 'Could this Christopher Dovecote perhaps be something like a being that has split off from my own self? An imaginary figure that has taken on independent, if transitory, existence and which I, without realising it, have brought into the world, as is said to happen to people who believe they see apparitions and even converse with them?'

As if this invisible being had been reading my thoughts, he immediately interrupted the story and used my hand to insert the following strange answer:

"And you yourself, sir," (this formal address from one so intimately related to me sounded like mockery) "you and all those humans who assume they are individual beings, are you anything other than 'chips' off some greater self, off the great self that is called God?"

Since then I have spent much time reflecting on the meaning of this extraordinary question, for I hoped it might provide the key to the mystery surrounding Christopher Dovecote. At one point I thought my ponderings were leading me somewhere, but then I received another bewildering message. It read:

"Every man is a dovecote, but not everyone is a Christopher. Most Christians merely imagine they are. The white doves fly in and out of a genuine Christian."

From then on I gave up all hope of ever solving the mystery, and at the same time I abandoned the idea that perhaps – following the ancient theory that human beings have several incarnations on earth – I might have been this Christopher Dovecote in an earlier existence.

What I would most like to believe is that what guided my hand over the page is an eternal force, free, self-sufficient and liberated from all constraints of shape and form; but sometimes, when I wake from dreamless sleep in the morning, I see, between eyeball and lid, like a memory of the night, the image of a white-haired, clean-shaven old man, tall and as slim as a youth, and for the rest of the day I cannot get rid of the feeling that that must be Christopher Dovecote.

This feeling is often accompanied by the strange idea that he lives beyond time and space, and that when death shall stretch out its hand to take me, he it will be who will enter on the inheritance of my life.

But what is the point of such reflections, which are of no concern to other people? There follow the revelations of Christopher Dovecote, in the often fragmentary form in which they came to me, with nothing added or left out.

Chapter 1

Christopher Dovecote's First Revelation

For as long as I can remember, the people in the town have maintained that my name is Dovecote.

When I was a boy, trotting from house to house in the twilight, bearing a long pole with a glowing wick at the end to light the lamps, street-urchins would march before me, clapping their hands and singing, "Doo'cot, Doo'cot, diddle diddle Doo'cot".

I did not get angry with them, even if I never joined in.

Later, the grown-ups took up the name and used it whenever they wanted something from me.

It was different with my first name of Christopher. That was written on a scrap of paper which was hanging round my neck when I was found one morning as a tiny baby, naked on the steps of St. Mary's. Presumably my mother wrote it before she left me there.

It is the only thing I have from her, and that is why I have always regarded the name of Christopher as something sacred. It has imprinted itself on my body, and I have borne it through life like a birth certificate issued in eternity which no one can steal from me. It kept on growing and growing, like a seed emerging from the darkness, until it once more appeared as what it had been from the very beginning, fused with me and accompanied me to the world of incorruptibility. Just as it is written, 'Being born again, not of corruptible seed, but of incorruptible'.

Jesus was baptised when he was a grown man and fully aware of what was happening: the name that was his *self* came down to earth. Nowadays people are baptised as infants: how can they grasp the significance of what has happened to them?! They wander through life towards the grave, like puffs of mist that the wind drives back to the swamp; their bodies decay, and they have no part in that which will rise again: their name.

But, insofar as any man can say of himself "I know", I know that I am called Christopher.

There is a legend current in the town that St. Mary's was built by a Dominican, Raimund de Pennaforte, from donations sent by unknown people from all over the world.

Over the altar is an inscription, "Flos florum: thus will I be revealed after three hundred years." A painted board has been nailed over it, but it keeps on falling down; every year on Lady Day.

It is said that on certain nights of the new moon, when it is so dark you can hardly see your hand before your eyes, the church casts a white shadow on the black market square. That is supposed to be the figure of the White Dominican, Pennaforte.

We children from the Home for Orphans and Foundlings had to go to confession for the first time when we were twelve years old.

"Why did you not come to confession?" the Chaplain barked at me the next morning.

"I did go to confession, Father."

"You're lying". Then I told him what had happened:

"I was standing in the church, waiting to be called, when a hand waved to me, and when I entered the confessional I found a white monk there who asked me three times what I was called. The first time I did not know; the second time I knew, but forgot before I could speak; the third time a cold sweat broke out on my brow, my tongue was paralysed, I could not speak, but a voice in my breast screamed, 'Christopher!' The white monk must have heard, for he wrote the name down in a book, and pointed to it and said, 'Henceforth you are entered in the Book of Life.' Then he blessed me and said, 'I forgive you your sins, your past and your future ones'."

At these last words, which I had spoken very softly, so that none of my classmates should hear, for I was afraid, the Chaplain stepped back in horror and made the sign of the cross.

That very same night was the first occasion when I left the house in some inexplicable manner and without being able to

explain how I returned home. I had gone to sleep in my nightshirt and had woken in my bed in the morning, fully dressed and with dusty boots on. In my pocket were some alpine flowers, which I suppose I must have picked in the mountains.

It happened again and again, until the supervisors in the orphanage found out about it and beat me because I could not say where I had been.

One day I was sent to see the Chaplain in the monastery. He was with the old gentleman who was later to adopt me, and I guessed that they had been talking about my nightwalks.

"Your body is not yet ripe. It must not accompany you. I will tie you down", said the old gentleman as he lead me by the hand, with an odd gasp for breath after every sentence, to his house. My heart was fluttering with fear, for I did not understand what he meant.

The door to the old gentleman's house was made of iron and decorated with huge nails; punched into the metal were the words: Baron Bartholomew von Jöcher, Freeman and Honorary Lamplighter. I could not understand how a nobleman came to be a lamplighter. Reading it, I felt as if all the miserable knowledge they had taught me at school were falling from me like scraps of paper, so filled with doubt was I, that I was incapable of thinking clearly at all.

Later, I learned that the Baron's line had been founded by a simple lamplighter who had been ennobled, though for what I do not know. Since then the coat of arms of the Jöchers has shown, along with other emblems, an oil-lamp, a hand and a pole, and from generation to generation they have been Freemen of the town and received a small pension, irrespective of whether they perform the office of lighting the street-lamps or not.

The day after my arrival the Baron commanded me to take up the duties of lamplighter. "Your hand must learn the task your spirit will later carry on", he said. "However low the occupation, it will be ennobled when the spirit can take it over. A task that the spirit refuses to inherit is not worthy of being per-

formed by the body."

I gazed at the old gentleman in silence, for at that time I did not yet know what he meant.

"Or would you rather be a merchant?" he asked in a friendly, mocking tone.

"Should I put the lights out again in the morning?" I asked shyly.

The Baron stroked my cheek. "Of course; when the sun comes, people need no other light."

Occasionally when the Baron talked to me he had a strangely furtive look; there seemed to be a mute question lurking in his eyes. Was it "Do you understand at last?", or did it mean "I am worried that you may have guessed"? At such times I often felt a fiery, burning sensation in my breast, as if the voice that had shouted the name of Christopher to the white monk at my confession were giving some answer I could not hear.

The Baron was disfigured by a huge goitre on his left side which was so big that the collar of his coat had to be cut open down to the shoulder so as not to hamper his neck. At night, when it was hanging over the back of the armchair, looking like the body of a man who had been beheaded, the coat often caused me a sensation of indescribable horror. I could only free myself from it by thinking of the friendly influence the Baron radiated through life. In spite of his affliction, and the almost grotesque sight of his beard sticking out like a bristly brush from his goitre, there was something uncommonly fine and delicate about my foster-father, the child-like helplessness of someone who could not hurt a fly, which was even intensified on the infrequent occasions when he put on his threatening look and stared at you severely through the thick lenses of his old-fashioned pince-nez.

At such moments he always looked to me like a huge magpie, squaring up to you for a fight, whilst its eyes, on the look-out for the slightest danger, can hardly conceal its fear, as if it were saying, "You wouldn't have the cheek to try and catch me, would you?"

22

The house of the Jöcher family, where I was to live for so many years, was one of the oldest in the town. It had many storeys, and each generation of the Baron's forebears had made its home in rooms one floor higher than the previous one, as if their longing to be nearer to heaven had grown ever stronger.

I cannot remember the Baron ever entering those older apartments, which stared out onto the street with blind, grey windows; he and I occupied a few bare, whitewashed rooms high under the flat roof.

In other places, the trees grow up from the ground and people walk beneath them; we had an elderberry tree with fragrant white flowers growing high above us on the roof in a rusty old iron tub originally intended to gather the rainwater, the outlet of which was now blocked up with earth and dead, rotting leaves.

Far below, a broad, waveless river, grey with water from the glaciers, ran along the foot of the ancient pink, ochre or light-blue houses with uncurtained windows, and roofs that looked like moss-green hats without brims. It flows in a circle round the town, which is like an island, caught in a noose of water; it approaches from the south, then curves to the west before turning back to the south again, where it is only separated from the spot where it began its embrace by a narrow neck of land, on which our house is the last building; finally it disappears behind a green hill.

You can reach the other, wooded bank, where sandy slopes tumble down into the water, over the wooden bridge with planks the height of a man on either side and a floor of rough, bark-covered trunks, which tremble when the ox-carts cross it. From our roof, we can see far out into a landscape of fields and meadows where, in the hazy distance, the mountains hover in the air like clouds, and the clouds press down upon the earth like heavy mountains.

From the middle of the town there rises up a long, fortress-like building, which now serves no other purpose than to catch the glare of the autumn sun in fiery, lidless windows. In the deserted market place, littered with the huge umbrellas of the

stallholders lying like giants' toys forgotten among piles of upturned baskets, the grass grows between the cobbles. Sometimes on Sundays, when the walls of the baroque Town Hall are scorched by the heat, the muffled tones of a brass band, borne along by a cool breeze, come out of the ground, growing louder as the door of the Post Inn, usually referred to as Fletzinger's, suddenly yawns wide and a wedding procession in colourful costume sets off with measured steps for the church; beribboned young men wave their festive wreaths and, at the head, is a band of young children with, far in front and nimble as a mountain goat in spite of his crutches, a tiny, ten-year-old crippled boy, bubbling over with joy, as if the happiness of the occasion were for him alone, whilst all the rest behave with due solemnity.

On that first evening, when I was already in bed and about to go to sleep, the door opened, and I was seized with fear once more, for the Baron came up to me, and I thought he was going to tie me down, as he had threatened. But he simply said, "I want to teach you to pray; none of them know how to pray. We do not pray with words, we pray with our hands. People who pray with words are begging. We should not beg. The spirit knows what we need. When the palms of our hands touch each other, the left and the right aspects of man are closed in a chain. Thus the body is bound fast, and a flame rises free from our fingertips as they point upwards. That is the secret of prayer; nowhere is it written down."

That was the first night when I walked without waking the next morning fully dressed in my bed and with dusty boots.

Chapter 2

The Mutschelknaus Family

Our house is the first in the street which memory tells me is called Baker's Row. It is the first and stands alone. On three sides it looks out over the open countryside, from the fourth I can touch the wall of the house next door if I open the window on the stairs and lean out, so narrow is the alleyway that separates the two buildings.

The alley between them has no name, it is no more than a steep passageway, a passage that is probably unique in the world, linking, as it does, two left banks of a river with each other; it cuts across the neck of land surrounded by a noose of water on which we live.

Early in the morning, when I set off to put the lamps out, a door opens in the neighbouring house and a broomstick appears and brushes wood-shavings into the river, which then carries them on a journey right round the town, to wash them, half an hour later and scarcely fifty yards from the other end of the passageway, over the weir, where it takes its thunderous leave of the town.

This end of the passageway joins Baker's Row; on the corner, above a shop in the neighbouring house, hangs a sign:

Adonis Mutschelknaus & Co.
"Fine Funeral Caskets"

It used to say, "Joiner and Coffin-Maker", which you can still clearly see when it is raining and the sign is wet; then the old writing shines through.

Every Sunday Herr Mutschelknaus, his wife Aglaia and his daughter Ophelia go to church, where they sit in the front row.

That is, Frau and Fräulein Mutschelknaus sit in the front row; Herr Mutschelknaus sits in the third row, in the corner seat, beneath the wooden statue of the Prophet Jonah, where the darkness is deepest.

How ridiculous it all seems to me, after all these years, how ridiculous and how inexpressibly sad!

Frau Mutschelknaus is always enveloped in a rustle of black silk, from which her crimson, velvet-covered prayer-book shrieks out like a Hallelujah in colour. She lifts her skirts a respectable inch to reveal her little pointed boots of matt-black, elasticated prunello as she cautiously negotiates every puddle; under the pink powder on her cheeks a dense network of fine purple veins betrays the approach of middle age; her eyes, usually so expressive, are modestly veiled by their carefully mascara'd lashes, for when the bells call mankind to appear before their God, it is not seemly to radiate sinful feminine charm.

Ophelia is wearing a flowing, Grecian garment and a band of gold round the silky, ash-blond locks that fall to her shoulders and are crowned, as always, by a wreath of myrtle. She walks with the serene, unruffled gait of a queen.

My heart always beats faster whenever I think of her.

When she goes to church she is always heavily veiled, and it was only much later that I saw her face with the large, dark, dreamy eyes, which contrast so strangely with her blond hair.

Herr Mutschelknaus, in his long, baggy black coat, usually walks a few paces behind the two ladies. Whenever he forgets and walks beside them, Frau Aglaia immediately whispers to him, "Half a step back, Adonis."

He has a long, thin, mournful face with sunken cheeks, sparse, reddish facial hair and a beak of a nose jutting out in front; his convex forehead merges into a bald pate which, with its fringe of moth-eaten hair, makes him look as if he has thrust his head through a mangy pelt and then forgotten to brush off the bits of fur. On every formal occasion Herr Mutschelknaus dons his top hat and has to wedge it on with an inch-thick pad

of cotton wool between the brim and his forehead. On weekdays he is never seen; he eats and sleeps in his workshop on the ground floor. The ladies of the family occupy several rooms on the third floor.

It must have been three or four years after the Baron had taken me in before I realised that Frau Aglaia and Ophelia and Herr Mutschelknaus belonged together.

From first light until after midnight the narrow passageway between the two houses is filled with a monotonous hum, as if there were a restless swarm of bumble-bees somewhere deep underground; when the air is still, the soft drone reaches us in our rooms high above. At first it attracted my attention, and I felt compelled to listen when I should have been learning my lessons, without it ever occurring to me, however, to ask where it came from. We do not look for the causes of constant phenomena, we accept them as a matter of course, however unusual they might in fact be. It is only when our nerves suffer a shock that we become curious – or run away.

I gradually became accustomed to the noise, as if it were a ringing in my ears; so accustomed, indeed, that whenever it suddenly stopped at night I would start from my sleep, thinking someone had hit me.

One day, when she rushed round the corner with her hands over her ears and knocked a basket of eggs out of my hand, Frau Aglaia excused herself by saying, "Oh, goodness me, my dear child, that's what comes of all that dreadful joinering by my ... my breadwinner. And ... and ... and his assistants", she added, as if she had let out a dire secret.

'Aha, it's Herr Mutschelknaus' lathe that makes that humming noise', I deduced.

It was only later that I learnt – from Mutschelknaus himself – that he had no assistants at all and that the '& Co.' consisted of himself alone.

One dark winter's evening, when there was no snow, I was just raising my pole to open the glass of the lamp by the corner,

in order to light it, when I heard someone whisper, "Psst, psst! Herr Dovecote." Standing beckoning to me from the alleyway was the carpenter, Mutschelknaus, in a green baize apron and slippers with tiger's heads embroidered in coloured beads.

"Herr Dovecote, if it's at all possible, do you think you could leave it dark tonight? Please don't think", he went on, when he saw how surprised I was, although I felt too timid to ask him his reasons, "that I want to lead you astray and make you neglect your duty, but my wife's reputation is at stake, if people should find out the job I've taken on. And my daughter's future as an actress would be ruined for ever. What's going to be done here tonight must be hidden from human sight!" I took an involuntary step backwards, so horrified was I by the old man's tone and the way his features were distorted with fear. "No, no, please don't run away, Herr Dovecote. It isn't anything wrong. Though if it comes out, I shall have to throw myself in the river! You see, the fact of the matter is, I've had an order from a customer in the city that's not quite, well, respectable – the order that is – and we're going to load it on the cart and send it off tonight, when everyone's asleep. Yes, that's about the long and the short of it."

I gave a sigh of relief. Even if I had no idea what it was all about, I was at least sure it was something completely harmless.

"Would you like me to help you with the loading, Herr Mutschelknaus?" I offered.

The old carpenter was so delighted he almost embraced me. "But won't the Baron hear of it?" he asked the next moment, his old fears returning. "And are you allowed to come out that late? You're so young?"

"My foster-father will know nothing at all about it", I assured him.

At midnight I heard someone softly calling my name from the street below.

I slipped down the stairs and saw a cart standing in the shadows. Pieces of cloth had been wrapped round the horses'

hooves so that they would not be heard as they trotted along. The carter was standing beside the shaft and grinned every time Herr Mutschelknaus came out of his shop lugging a basket full of large, round, brown-painted wooden rings with lids attached, each with a knob in the middle.

I hurried over to help him load them, and in half an hour the cart was filled to the brim and swaying over the wooden bridge before it was lost in the darkness.

With a deep sigh of relief, the old man drew me into his workshop, in spite of my reluctance. What little light that came from the tiny petroleum lamp hanging from the ceiling seemed to be absorbed by the white disc of the freshly planed table, on which stood a jug of weak beer and two glasses of which one, of beautifully cut crystal, was obviously intended for me. The rest of the room stretched away into darkness. Only gradually, as my eyes became accustomed to the light, could I distinguish the various objects. A steel shaft ran from wall to wall. During the day it was driven from outside by a water-wheel; now several hens were sleeping on it. Over the lathe, leather drive-belts hung down like gallows nooses, and in the corner stood a wooden statue of Saint Sebastian, pierced with arrows. Each arrow had its roosting hen. By the head-end of a wretched trestle, which presumably served the old man as a bed, was an open coffin in which a few rabbits shifted in their sleep from time to time.

The only decoration in the room was a picture in a golden frame surrounded by a laurel wreath. It represented a young woman in a theatrical pose, with eyes closed and mouth half-open; the figure was naked apart from a fig leaf, but white as snow, as if it were a model who had been painted over with plaster of Paris.

Herr Mutschelknaus blushed when he saw me stop in front of the picture, and he immediately began to reel off an explanation, "It's my lady wife, at the time when she bestowed her hand upon me. You see, she was", he cleared his throat, "a marble nymph. Ah, yes, Aloysia – that is, Aglaia; of course,

Aglaia. It was, you see, my lady wife's misfortune, as a tiny baby, to be christened with the rather common name of Aloysia by her dear departed parents. But you won't tell anyone, will you, Herr Dovecote? Otherwise our daughter's artistic reputation would suffer. Hm. Well." He led me to the table, bowed as he offered me a chair and poured me some of the weak beer.

He seemed to have completely forgotten that I was still not fifteen and little more than a boy; he spoke to me as to a grown-up, as to a gentleman who stood far above him in rank and learning.

At first I thought he was just chatting to keep me amused, but then I realised, from his insistent, worried tone whenever I looked at the rabbits, that he wanted to divert my attention away from the shabby surroundings, so I tried to sit still and not let my eyes wander.

He had soon managed to talk himself into a fine state of agitation. Round red spots appeared on his hollow cheeks. I began to understand that his urgent assertions were a desperate attempt to justify himself – to justify himself to me!

At that time I was still very much a child, and most of what he said went far beyond my comprehension, so that an inexplicable feeling of horror gradually crept over me at the strange dissonances his words aroused. The horror of it etched itself deep on my soul, to reawaken long after I had reached manhood and more intensively with each passing year, whenever chance brought the scene back to mind. With my growing insight into the miseries to which existence condemns us, every word the old carpenter spoke that night grew more piercing, more naked in my memory, until they sometimes took on nightmare proportions. I would experience his wretched fate as my own, feel the darkness surrounding his soul as if I were trapped within it, torn apart by the terrible discord between the ghastly ludicrousness of his appearance and the grotesque yet deeply moving devotion with which he had sacrificed himself to a false ideal, such that even the Devil, had he wanted to delude him, could not have set a more malign snare.

On that night his story seemed to me, who was still a child, like the confession of a madman that was intended for other ears than mine. I was compelled to listen, whether I wanted to or not, held there by an invisible hand which wanted to drip poison into my veins.

There were times when, for a few seconds, I felt as decayed and decrepit as an old man, so vivid was the effect on me of Herr Mutschelknaus' delusion that I was not a young boy, but equal to, or beyond him in years.

"Oh, yes, she was a great artist, and famous" – thus he began. "Aglaia! No one in this miserable hole has any idea. And she doesn't want any of them to find out! You see, Herr Dovecote, I can't tell you the story the way I would like to. I can hardly even write. But it'll be our little secret, won't it? Just like all those ... all those lids beforehand? There is only one word I can write," – he took a piece of chalk out of his pocket – "this one: Ophelia.

And I can't read at all. You see, I'm" – he bent over to whisper in my ear – "a simpleton. My father, you see, was very strict, and once, when I was a little boy, because I let the glue burn, he shut me up for twenty-four hours in a metal coffin he had just finished, and said I was going to be buried alive. I believed him, of course, and all the hours I was in there were like an eternity in hell. I couldn't move, I could hardly even breathe. I was in such mortal fear, I clenched my teeth until the bottom ones at the front fell out. But", he added, very softly, "why did I let the glue burn, anyway? When they took me out of the coffin, I had lost my wits. And my tongue. It was ten years before I slowly started to speak again. But it'll be our little secret, won't it, Herr Dovecote? If people come to hear of my shameful past, my daughter's artistic career will be ruined! Hm. Well. – Then when my father was taken from me – he was buried in that very same metal coffin – and left me his business and his money – he was a widower – Providence sent an angel to comfort me, for I felt I would weep myself to death in my sorrow at the loss of my father: Herr Paris, the celebrated

theatre director, came to see me. You don't know Herr Paris? He comes every other day to instruct my daughter in the art of acting. He has the same name as Paris, the ancient Greek god, it was destiny from his earliest childhood. Well. Hm. At that time my present lady wife was still a maid. Hm. Well. That is, I mean, she was still a girl. Well. Hm. And Herr Paris was guiding her artistic career. She was a marble nymph in a private theatre in the capital. Hm. Well."

From the disjointed way he brought out each sentence, paused involuntarily, then abruptly went on, I realised that his memory kept on disappearing and reappearing. Like breathing in and out, his consciousness ebbed and flowed. 'He still hasn't recovered from the dreadful torture of the metal coffin', I sensed, 'he remains a man who has been buried alive.'

"Well, and when I inherited the business, Herr Paris came to the house and told me the celebrated marble nymph, Aglaia, had happened to see me at the funeral, as she was walking, unrecognised, through the town. Hm. And when she had seen me crying at my father's grave, she had said (Herr Mutschelknaus suddenly leapt to his feet and began to declaim, his little watery blue eyes fixed on the empty air, as if he could see the words in letters of fire), 'I will be a comfort and a support to this plain, simple man, a light that shineth in the darkness, never to be extinguished. And I will bear him a child, whose life shall be dedicated to art alone. I will open its spirit to the sublime, even though my heart should break in the dreary desert of the workaday world. Farewell, Art! Farewell, Fame! Farewell, ye haunts of glory! Aglaia is departing, never to return.' Hm. Well." He clasped his hand to his forehead and then, as if memory had suddenly departed, slowly sat down on his stool.

"Well. Herr Paris sobbed and tore his hair. When the three of us were sitting together at the wedding breakfast. And he kept on crying out. 'My theatre will be ruined if I lose Aglaia. I'm finished.' Hm. The thousand crowns I forced on him, so that at least he wouldn't lose everything, were nowhere near enough, of course. Well. Hm. From then on he's suffered from melan-

choly. Only now, since he's discovered our daughter's great dramatic talent, has his health improved a little. Hm. Well.

She must have inherited it from her mother. Yes, some children are suckled by the muse in their cradles. Ophelia! Ophelia!" He was suddenly seized by a wild fit of enthusiasm, and grasped me by the arm and shook me violently. "Do you know, Herr Dovecote, Ophelia, my child, is a gift from God? Herr Paris keeps telling me, when he comes to the workshop for his salary, 'The divine Vestalus himself must have been present when she was conceived, Herr Mutschelknaus.' Ophelia –", his voice sank to a whisper, "but this must be a secret between us, like all those ... all those ... lids – Ophelia was born after only six months. Hm. Ordinary children need nine months. Well. But it wasn't a miracle. Her mother, too, was born under a royal star. Hm. But unfortunately it wasn't very constant. The star, that is. My wife doesn't want anyone to know, but I can tell you, Herr Dovecote. Do you know that she almost sat on a throne?! And if it hadn't been for me – it brings the tears to my eyes, just to think of it – she could be riding in a fine carriage behind six white horses. And she renounced it all for me. Hm. Well. And that about sitting on a throne", he solemnly raised three fingers, "is the honest truth; as I hope to be saved, I swear it's no lie. I had it from Herr Paris himself. In his younger days he was Grand Fixer to the King of Arabia in Baghdad. He used to rehearse the Imperial Harem for His Majesty. Hm. Well. And Aglaia, who is now my wife, with her artistic talent, had already reached the position of first lady-in-waiting at the left hand of the King – His Majesty used to call her his 'Miss Thérèse'. Then the King was murdered and Herr Paris and my wife fled by night across the Nile. Well. Hmm. And that's when she became a marble nymph, as you know. In a private theatre that Herr Paris was director of at the time. Until she renounced fame and fortune. Herr Paris gave up the theatre as well; the only thing he lives for now is Ophelia's future. Hm. Well. 'We all must live for her alone', he keeps on saying. 'And to you, Herr Mutschelknaus, has fallen the noble task of doing your utmost

to make sure Ophelia's artistic career is not nipped in the bud by lack of money.' So you see, Herr Dovecote, that's why I accept such unsavoury commissions as ... you know what I mean. Making coffins doesn't bring in much. So few people die. Hm. Well. Her training I could manage, but the world-famous poet, Professor Hamlet from America, demands so much money. I've had to give him an IOU, and now I'm paying it off. This Professor Hamlet, you see, is Herr Paris' foster-brother, and when he heard of Ophelia's great talent, he wrote a play specially for her. The title is *The King of Denmark*. In it the crown prince wants to marry my daughter, but his mother won't allow it, so my Ophelia throws herself into the river." The old man paused for a moment, then shouted out loud, "My Ophelia throw herself into the river! When I heard that, it almost broke my heart. No, no, no, my darling Ophelia, my everything, must not throw herself into the river! Not even in a play. Hm. Well. I went down on my knees to Herr Paris and implored him until he wrote to Professor Hamlet. And Professor Hamlet has agreed to arrange it so that my Ophelia will marry the crown prince and not drown, provided I give him an IOU. Herr Paris wrote out the IOU and I made my three little crosses at the bottom. Perhaps you think it's silly, Herr Dovecote, because it's only a play and not real life. But you see, in the play my Ophelia will still be called Ophelia. You know, Herr Dovecote, I'm only a simpleton, but what if my Ophelia really should drown after all? Herr Paris is always saying art is truer than real life, what if she should throw herself into the river? What would become of me then? Wouldn't it have been better if I'd suffocated in that metal coffin in the first place?!"

The rabbits started to make a noise, scuffling about in their coffin. Mutschelknaus came to with a start and muttered, "Damn bucks!"

There was a long pause. The old carpenter had lost the thread of his story. He seemed to have completely forgotten my presence; his eyes did not see me. After a while he stood up, went to the lathe, put the belt over the drive-wheel and set it going.

"Ophelia! No, my Ophelia must not die", I heard him murmur. "I must work, work, otherwise he won't alter the play and –"

His last words were drowned by the hum of the machine.

I quietly slipped out of the workshop and went up to my room. In bed, I put my hands together and, I don't know why, beseeched God to protect Ophelia.

Chapter 3

The Nightwalk

That night I had a strange experience. Others would call it a dream, for men have only that one, inadequate word to describe everything that happens to them when their body is asleep.

As always before I went to sleep, I had folded my hands so that, as the Baron put it, "the left lay on the right".

It was only through experience over several years that I came to realise what the purpose of this measure was. It could be that any other position of the hands would serve the same purpose as long as they result in the feeling that 'the body is bound'.

Every time since that first evening in the Baron's house I had lain down to sleep in this manner, and every morning I had woken feeling as if I had walked a long way in my sleep, and every time I was relieved to see that I was undressed and not wearing dusty boots in bed and need not fear being beaten for it, as had happened in the orphanage. But in the light of day I had never been able to remember where I had walked in my dream. That night was the first time the blindfold was taken from my eyes.

The fact that shortly before Mutschelknaus had treated me in such a remarkable way, like a grown-up, was probably the hidden reason why a self – perhaps my 'Christopher' – which had until then slept within me, now awoke to full consciousness and began to see and to hear.

I began by dreaming I had been buried alive and could not move my hands or my feet; but then I filled my lungs with mighty breaths and thus burst open the lid of the coffin; and I was walking along a white, lonely country road, which was more terrible than the grave I had escaped from, for I knew it would never come to an end. I longed to be back in my coffin, and there it was, lying across the road.

It felt soft, like flesh, and had arms and legs, hands and feet,

like a corpse. As I climbed in, I noticed that I did not cast a shadow, and when I looked down to check, I had no body; then I felt for my eyes, but I had no eyes; when I tried to look at the hands that were feeling for them, I could see no hands.

As the lid of the coffin slowly closed over me, I felt as if all my thoughts and feelings as I was wandering along the white road had been those of a very old, if still unbowed, man; then when the coffin lid closed, they disappeared, just as steam evaporates, leaving behind as a deposit the half blind, half unconscious thoughts which normally filled the head of the half-grown youth that I was, standing like a stranger in life.

As the lid snapped shut, I woke in my bed.

That is, I thought I had woken up.

It was still dark, but I could tell by the intoxicating scent of elderflowers that came streaming in through the open window, that the earth was giving off the first breath of the coming morning and that it was high time for me to put out the lamps in the town.

I picked up my pole and felt my way down the stairs. When I had completed my task, I crossed the wooden bridge and climbed up a mountain; every stone on the path seemed familiar, and yet I could not remember ever having been there before.

In the high meadows, still dark green in the glowing half-light and heavy with dew, alpine flowers were growing, snowy cotton grass and pungent spikenard.

Then the farthest edge of the sky split open, and the invigorating blood of the dawn poured into the clouds.

Blue, shimmering beetles and huge flies with glassy wings suddenly rose from the earth with a buzzing sound and hovered motionless in the air at about head height, all with their heads turned towards the awakening sun.

When I saw, felt and comprehended this grandiose act of prayer from mute creation, a shiver of deepest emotion ran through my every limb.

I turned round and went back towards the town. My shadow

preceded me, gigantic, its feet inseparably attached to mine. Our shadows: the bond that ties us to the earth, the black ghost that emanates from us, revealing the death within us, when light strikes our bodies!

The streets were blindingly bright when I entered them.

The children were making their noisy way to school.

'Why aren't they chanting, 'Doo'cot, doo'cot, diddle diddle doo'cot' at me as usual?' was the thought that awoke in my mind. 'Can they not see me? Have I become such a stranger to them that they don't know me any more? I have always been a stranger to them', I suddenly realised with a startlingly new awareness. 'I have never been a child! Not even in the orphanage when I was small. I have never played games as they do. At least whenever I did, it was only a mechanical motion of my body without my desire ever being involved; there is an old, old man living inside me and only my body seems to be young. The carpenter probably felt that yesterday, when he spoke to me as to a grown-up.'

It suddenly struck me, 'But yesterday was a winter evening, how can today be a summer morning? Am I asleep, am I walking in my sleep?' I looked at the street lamps: they were out, and who but I could have extinguished them? So I must have been physically present when I put them out. 'But perhaps I am dead now and being in a coffin was real and not just a dream?' I decided to carry out a test, and went up to one of the schoolboys and asked him, "Do you know me?" He did not reply, and walked through me as through empty air.

'I must be dead then', I concluded, unconcerned. 'Then I must take the pole back home quickly, before I start to decompose', came the voice of duty, and I went upstairs to my foster-father.

In his room I dropped the pole, making a loud noise.

The Baron heard it – he was sitting in his armchair – turned round and said, "Ah, there you are at last."

I was glad that he could see me, and concluded that I could not have died.

The Baron looked as he always did, was wearing the same coat with the jabot of mulberry lace that he always wore on feast days, but there was something about him that made him seem indefinably different. Was it his goitre? No, that was neither larger nor smaller than usual.

My eyes wandered round the room – no, that was unchanged, too. There was nothing missing, nothing had been added. Leonardo da Vinci's *Last Supper*, the only decoration in the room, was on the wall as usual; everything was in its usual place. Just a moment! That green plaster bust of Dante with the severe, sharp, monkish features, was it not on the right-hand end of the shelf yesterday? Had someone moved it round? It was on the left now.

The Baron noticed me looking round and smiled.

"You have been on the mountain?" he said, pointing to the flowers in my pocket which I had picked on the way.

I mumbled some excuse but he waved it aside. "I know; it's beautiful up there. I often go myself. You have often been there before, but you always forgot it afterwards. Young minds can't retain anything, their blood is still too hot; it washes the memory away. Did the walk make you tired?"

"Not on the mountain, but on ... on the white country road", I said, unsure whether he knew about that too.

"Ah, yes, the white road", he mused, "there are not many who can stand that. Only someone who is born a wanderer. It was because I saw that in you, all those years ago in the orphanage, that I brought you to live with me. Most people fear the road more than they fear the grave. They get back into their coffins because they think that is death and that it will bring them peace; but in reality the coffin is life, is the flesh. Being born on earth is nothing other than being buried alive! It is better to learn to walk the white road. Only one must not think of the end of the road, for it has no end. It is infinite. The sun on the mountain is eternal. Eternity and infinity are two different things. The only person for whom infinity and eternity are the same is one who seeks eternity in infinity and not the 'end'. You must walk along

the white road for the sake of the walk itself, for the pleasure of walking and not to exchange one transient resting place with another.

Rest – not a resting place – can only be found in the sun on the mountain. It stands still and everything revolves round it. Even its herald, the dawn, radiates eternity, and that is why the insects and flies worship it and stay still in the air until the sun comes. And that is why you did not feel tired when you climbed the mountain."

He suddenly gave me a close look. "Did you see the sun?" he asked.

"No, father, I turned back before it rose."

He gave a satisfied nod. "That is good", adding under his breath, "otherwise we would have nothing more to do with each other. And your shadow went before you, down towards the valley?"

"Yes. Of course ..."

He ignored my surprise.

"Anyone who sees the sun", he continued, "seeks eternity alone. He is lost for the road. They are the saints of the church. When a saint crosses over, he is lost to this world, and to the next one too. But what is worse, the *world* has lost *him;* it is orphaned! You know what it means to be a foundling; do not consign others to the fate of having neither father nor mother. Walk the road. Light the lamps until the sun comes of its own accord."

"Yes", I stuttered, thinking with horror of the terrible white road.

"Do you know what it means that you got back into your coffin?"

"No, father."

"It means that for yet a little while you will share the fate of those who are buried alive."

"Do you mean Mutschelknaus, the carpenter?" I asked in my childish way.

"I know no carpenter of that name; he has not yet become visible."

40

"Nor his wife and ... and Ophelia?" I asked, feeling myself blush.

"No; nor Ophelia either."

'Strange', I thought. 'they live just across the road, and he must see them every day.'

For a while we were both silent, and then I suddenly burst out sobbing, "But that is horrible! To be buried alive!"

"Nothing is horrible, my child, that you do for the sake of your soul. I, too, have been buried alive at times. On earth I have often met people who are wretched and in great need and who rail bitterly at the injustice of fate. Many of them sought comfort in the doctrine that came to us from Asia, the doctrine of the Karma which maintains that no being suffers unless it has sown the seed within itself in a former existence. Others seek comfort in the dogma of the unfathomable nature of God's designs. They all seek comfort, but none have *found* it.

I have lit a lamp for such people by inserting a thought" – his smile as he said that was almost grim, and yet at the same time as friendly as ever – "in their minds, but so delicately that they believe it came of its own accord. I ask them this question: 'Would you accept the agony of dreaming tonight, as clearly as if it were reality, that you lived through a thousand years of unimaginable poverty, if I assured you now that as a reward you would find a sack of gold outside your door when you woke in the morning.?'

'Yes! Of course!' is the answer every time.

'Then do not bemoan your fate. Are you sure that you did not choose this tormenting dream called life on earth which, at the worst, lasts seventy years, of your own free will, in the hope of finding something much more glorious than a miserable bag of money when you woke? Of course, if you sow a 'God with unfathomable designs' you will one day reap him as a malevolent devil.

Take life less seriously and dreams more so, then things will improve, then the dream can become your leader instead of, as now, going round as a garish clown in the motley shreds of our

daytime memories.'

Listen, my child. There is no such thing as a vacuum. That sentence conceals the secret that everyone must unveil who wants to be transformed from a perishable animal to an immortal consciousness. Only you must not apply the words merely to external nature; you must use them like a key to open up the spiritual realm; you must transform their meaning. Look at it like this: someone wants to walk, but his feet are held fast in the earth; what will happen if his will to walk does not weaken? His creative spirit, the primal force that was breathed into him at the beginning, will find other paths for him to tread, and that force within him that can walk without feet, will walk in spite of the earth, in spite of the obstacle.

The creative will, man's divine inheritance, is a force of suction; this suction – you must understand it in a metaphorical sense! – would of necessity create a vacuum in the realm of first causes, if the expression of the will were not eventually followed by its fulfilment. See: a man is ill and wants to get better; as long as he resorts to medicines, the power of the spirit, which can heal better and more quickly than any medicine, will be paralysed. It is as if someone wanted to learn to write with the left hand: if he always uses the right, he will never learn to do it with the left. Every event that occurs in our life has its purpose; nothing is pointless; an illness says to a man, 'Drive me away with the power of the spirit so that the power of the spirit will be strengthened and once more be lord over the material world, as it was before the Fall.' Anyone who does not do that and relies on medicines alone has not grasped the meaning of life; he will remain a little boy playing truant. But anyone who can command with the field marshal's baton of the spirit, scorning the coarser weapons that only the common soldier uses, will rise again and again; however often death strikes him down, he will yet be a king in the end. That is why men should never weaken on the path to the goal they have set themselves; just as sleep is only a brief rest, so is death. You do not begin a task in order to abandon it, but to complete it. A task, however

unimportant it appears, once begun and left half finished, corrodes the will with its poison, just as an unburied corpse pollutes the air of the whole house.

The purpose of our life is the perfection of the soul; if you keep that goal firmly in your sights, and in your mind and your heart every time you begin or decide something, then you will find yourself possessed by a strange, unknown calm, and your destiny will change in an incomprehensible way. Anyone who creates as if he were immortal – not for the sake of the object of his desires, that is a goal for the spiritually blind, but for the sake of the temple of his soul – will see the day come, even if it is after thousands of years, when he can say, 'I will it' and what he commands will be there, will happen, without needing time to ripen slowly.

Only then will the point be reached where the long road ends. Then you can look the sun in the face without it burning your eyes. Then you can say, 'I have found a goal because I sought none.' Then the saints will be poor in understanding compared with you, for they will not know what you know: that eternity and rest can be the same as the road and the infinite."

These last words were far beyond my comprehension; it was only much later, when my blood was cool and my body manly, that they reappeared, clear and alive. But that morning I heard them with a deaf ear; I just looked at Baron Jöcher and, in a sudden flash of recognition, I realised what it was that had struck me as different about him, an odd thing, his goitre was on the right side of his neck, instead of the left as usual.

Today it sounds ridiculous, but I was seized with a nameless horror: the room, the Baron, the bust of Dante on the shelf, myself, for one brief second everything was transformed into ghosts, so spectral and unreal that my heart froze in mortal fear.

That was the end of what I experienced that night.

Immediately afterwards I awoke in my bed, trembling with fear. The daylight was bright behind the curtains. I ran to the window: a clear winter's morning!

I went into the next room; the Baron was sitting at his desk, reading and wearing his usual working clothes.

"You've slept in late this morning, my lad", he called to me with a laugh when he saw me by the door, still in my nightshirt, my teeth chattering with inner cold. "I had to go and put out the lamps in the town instead of you. The first time for many years. But what's the matter with you?"

A quick glance at his neck and the last drops of fear trickled out of my blood: his goitre was back on its usual left side and the bust of Dante was in the same place as ever.

Another second, and the earth had once more swallowed up the dreamworld; there was an echo fading in my ear, as if the lid of the coffin had fallen to, and then everything was forgotten.

With growing haste, I told my foster-father everything that had happened to me; the only thing I held back was my meeting with the old carpenter, Mutschelknaus. Only at one point I asked, in passing, "Do you know Herr Mutschelknaus?"

"Of course", he answered cheerfully. "He lives down below. A poor, poor wretch, by the way."

"And his daughter ... Fräulein Ophelia?"

"Yes, I know ... Ophelia as well", said the Baron, with a sudden earnest air. He gave me a long, sad look, "Ophelia as well."

Quickly I went back to the nightwalk, for I could feel a blush spreading over my cheeks. "Papa, in my dream, why did you have your ... your left neck on the other side?"

The Baron thought for a long time. When he began to speak, he kept searching for the right word, as if he found it difficult to adapt what he had to say to my still undeveloped understanding:

"To make that clear to you, my son, I would have to give you an exceptionally complicated lecture lasting a whole week, and even then you wouldn't understand it. You'll have to content yourself with the few random thoughts I'll throw at you. Will you catch them? True teaching can only come from life or, better still, dreams.

Learning to dream is thus the first stage of wisdom. The world can give you cleverness; wisdom flows from your dreaming, whether it is a waking 'dream' (in which case we say, 'something just occurred to me' or, 'it has just dawned on me'), or a sleeping dream, in which we are instructed through symbolic images. Likewise all true art comes from the realm of dreams. The gift of invention as well. Men speak in words, dream in living images. The fact that they are taken from the happenings of the day has deceived many into thinking they are meaningless; which they are, of course, if you don't pay them any attention! In that case, the organ through which we dream will atrophy, just like a limb we do not use, and a valuable guide will fall silent: the bridge to another life, that is of much greater value than earthly life, will collapse in ruins. Dreaming is the footbridge between waking and sleeping; it is also the footbridge between life and death.

You mustn't take me for a great sage, my boy, just because last night my double told you so much that might seem marvellous to you. I have not yet reached the stage when I can claim that he and I are one and the same person. It is true, however, that I am more at home in that dreamland than many other people. I have become visible over there and lasting, so to speak, but I still always have to shut my eyes here when I want to open them over there, and vice versa. There are people for whom that is no longer necessary, but very, very few.

You remember that you could not see yourself, and had neither body, nor hands, nor eyes, when you lay down in the coffin again on the white road?

But the schoolboy couldn't see you, either! He walked right through you, as if you were empty air!

Do you know where that came from? You did not take the memory of the form of your earthly body over to the other side. Only someone who can do that – as I have learnt to – is visible to himself on the other side. He will create for himself a second body in dreamland, which will even become visible to others later on, however strange that might sound to you at the

moment. In order to achieve that, there are methods" – with a grin he pointed at the print of Leonardo's *Last Supper* – "which I will teach you when your body is mature and no longer needs to be bound. Anyone who knows them is capable of raising a ghost. With some people this 'becoming visible in the other realm' happens of its own accord, completely without method, but almost always only one part of them comes alive, usually the hand. That then often performs the most pointless acts, for the head is absent, and people who observe the effect cross themselves and talk of fiendish phantoms. You are thinking, how can a hand do something without its owner being aware of it? Have you never seen the tail of a lizard break off and writhe in apparent agony while the lizard stands by, in complete indifference? It is something like that.

The realm over there is just as real" ("or unreal", he added in an aside) "as this earthly realm. Each on its own is only a half, only together do they form a whole. You know the story of Siegfried: his sword was broken in two pieces; the cunning dwarf Alberich could not forge it together, because he was a creature of the earth, but Siegfried could.

Siegfried's sword is a symbol of that double life: the way to weld it together into one piece is a secret one must know, if one wants to be a knight.

The realm beyond is in fact even more real than this earthly one. The one is a reflection of the other, that is to say the earthly one is a reflection of 'beyond', not vice versa. Anything that is on the right over there" – he pointed to his goitre – "is on the left here.

Now do you understand?

That other man was my double. What he said to you I have only just now heard from your lips. It did not come from his knowledge, much less from mine; it came from yours!

Yes, yes, my lad, don't stare at me like that, it came from yours! Or rather", he ran his hand caressingly through my hair, "from the knowledge of the Christopher within you! Anything I can tell you, as one human animal to another, comes out of

human lips and goes into a human ear, and is forgotten when the brain decays. The only talk you can learn from, is from talking to – yourself! When you were talking to my double, you were talking to yourself! Anything a human being can tell you is, on the one hand, too little, and, on the other, too much. Sometimes it comes too soon, at others too late, and always when your soul is asleep. And now, my son", he turned back to his desk, "it's time you got dressed. You're surely not going to run around in your nightshirt all day?"

Chapter 4

Ophelia

The memories of my life have become like precious stones to me; when the time for observing them comes, and I have found a human hand I can bend to my will to write them down, I raise them from the watery depths of the past. Then, when I listen to the string of words as to a story from other lips, I feel as if they are glittering gems running through my fingers, and the past becomes present once more. To my eyes, they all gleam, the dull as well as the shining ones, the dark as well as the bright; I can look on them all with a smile in my heart, for I am for ever 'dissolved with corpse and sword'.

But there is one jewel among them which I can only raise with trembling hand. I cannot play with it as I can with the others. It gives off the sweet, intoxicating power of Mother Earth which goes straight to my heart.

It is like alexandrite, a precious stone which is dark green by day but suddenly shines with a red glow when you stare into its depths in the still of night.

I carry it with me like a drop of crystallised heart's-blood, ever fearful that it might dissolve into liquid once more and scorch me, if I should bear it close to my breast for too long.

For that reason I have shut away the memory of that span of time that for me bears the name of Ophelia and is a brief spring followed by a long autumn, as if in a glass ball in which lives the boy I used to be, half child, half youth. I look through the glass sides at myself, but it is like looking at a figure in a waxworks: it has lost all power to ensnare me with its magic.

And just as I see this image before me, awaking, changing, fading, so will I – a reporter who has left this world – describe it.

All the windows of the town are open, their ledges red with the geraniums in bloom; the chestnut trees that line the banks of

the river are festooned with living, scented, white spring candles. The air beneath the pale-blue, cloudless sky is mild and still. Over the meadows there is a flutter of colourful butterflies, as if a gentle breeze were playing with a thousand scraps of coloured tissue paper.

In the bright, moonlit nights, the eyes of the cats, spitting and yowling with the pangs of love, glitter from the silvery roofs.

I am sitting on the banisters in the stair-well, listening to the sounds coming from the open window of the third floor across the alley. The curtains are drawn, so I cannot see into the room, but two voices – one a deep, declamatory, man's voice, that I hate, and the other a soft, shy girl's voice – are carrying on a conversation which I find incomprehensible:

"To-o be-e or not to-o be-e, that is the question. Nymph, in thy orisons, be a-all my sins remember'd."

"Good my Lord, how does your honour for this many a day?" breathes the shy voice.

"Get thee-ee to a nunnery, Ophelia."

I am very eager to hear what will come next, but suddenly, as if the speaker had turned into a clockwork toy, the spring of which is beginning to unwind, the male voice, without any obvious reason, becomes a low, hurried gabble from which all I can fish out are a few meaningless sentences, "Why wouldst thou be a breeder of sinners? I am myself indifferent honest; if thou dost marry, I'll give thee this plague for thy dowry: be thou as chaste as ice, as pure as snow, or, if thou needs marry, marry a fool, and quickly too. Farewell."

To which the girl's voice shyly replies, "O! what a noble mind is here o'erthrown. O heavenly powers, restore him!"

Then both are silent, and I hear sparse applause. After half an hour of deathly hush, during which the smell of a greasy roast wafts from the window, a well-chewed cigar-butt usually flies, still glowing, out between the curtains, bounces off the wall of our house in a shower of sparks and drops onto the cobbles of the alleyway.

I sit there until late in the afternoon, staring across at the

49

house. My heart gives a joyful start each time the curtains move. Will Ophelia come to the window? And if it is she, should I leave my hiding place and show myself?

I have picked a red rose; will I dare to throw it across to her? I ought to have something to say to her as I do. But what?

It does not come to that, however. The rose begins to droop in my hot hand and there is no sign of life from across the alleyway. Only the smell of the meat has given way to that of roasted coffee.

Ah! At last. A woman's hands push the curtains apart. For a moment my head spins, then I clench my teeth and force myself to throw the rose through the open window.

A soft cry of surprise, then – Frau Aglaia Mutschelknaus appears at the window.

I cannot duck down quickly enough, she has already seen me.

I feel the blood drain from my cheeks; all is revealed.

But destiny has other ideas. Frau Mutschelknaus simpers, places the rose on her bosom, as if on a plinth, and bashfully lowers her eyes; then, when she raises her soulful gaze once more and realises that it is only me, a shadow flits across her features. But she inclines her head in thanks, and the simper widens to reveal one of her canines.

I feel as if a skull had smiled at me, and yet I am relieved! If she had guessed for whom the flower was intended, it would have all been over. An hour later I am even happy that it turned out the way it did. From now on I can leave a whole bunch of flowers on the window-ledge for Ophelia every morning: her mother will assume they are for herself.

Perhaps she'll even think they come from my foster-father, Baron Jöcher!

Life certainly teaches you a trick or two.

For a moment I have a nasty taste in my mouth, as if the mean thought had poisoned me, but the next minute it has gone, and I am wondering whether the best plan would not be to go to the cemetery straight away to steal some fresh roses. Later on

people come to pray at the graves, and in the evening the gates are locked.

Down in Baker's Row I meet Herr Paris, the actor, coming out of the alley in his creaky boots.

He knows who I am, I can tell by his look.

He is a fat, old, clean-shaven man with flabby cheeks and an alcoholic nose that quivers at every step. He is wearing a kind of loose velvet beret, his cravat is fastened by a pin with a silver laurel wreath on it, and across his paunch hangs a watch-chain woven from tresses of blond hair. His jacket and waistcoat are of brown velvet, his legs are tightly encased in bottle-green trousers, which are so long that at the bottom they have folds like a concertina.

Has he guessed that I'm going to the cemetery? And why I'm going to steal roses there? And for whom? That's silly, I'm the only one who knows that. I give him a defiant look and deliberately do not wish him a good morning, but my heart stands still for a second when I notice the hard, almost calculating stare he is giving me from beneath his half-closed lids; he stops, takes a reflective suck at his cigar and then closes his eyes, like someone who has just had a strange idea.

I walk past him as quickly as possible, but then, from behind me, I hear him clear his throat in a loud, unnatural manner, as if he were about to declaim a speech, "Hemhem, mhhm, hemm."

An ice-cold tremor runs down my spine, and I start to run; I can't help it, I have to run, even though something says, 'Don't! You're just giving yourself away."

In the first light of dawn I put out the lamps and then go back to sit on the banisters, although I know it will be hours before Ophelia comes and opens the window in the house across the way. But I am afraid I might sleep too long if I go back to bed instead of waiting here.

I have put three white roses on the window-ledge for her, and

51

I was so excited that I almost fell down into the alley as I did.

I pass the time imagining I am lying on the ground with broken limbs; they carry me to my room, Ophelia hears what has happened, guesses the cause, comes to my sick-bed and kisses me, tenderly, lovingly.

Thus I weave myself a childish, sentimental dream, then I blush inwardly at it, embarrassed that I can be so foolish; but the idea of suffering pain for Ophelia's sake is so sweet.

I tear myself away from my daydream. Ophelia is nineteen and a young lady, while I am only seventeen, although I am a little taller than she is. She would only kiss me in the way one kisses a child that has hurt itself. I like to think of myself as a grown man, and here I am imagining myself lying helpless in bed, being looked after by her. It is not manly, it is like a little boy.

So I dream myself into another fantasy: it is night and the town is asleep when suddenly flames are reflected on my window and a cry echoes through the streets; the neighbouring house is on fire! There is no hope of saving the inhabitants; Baker's Row is blocked by blazing beams!

In the room across the alleyway the curtains go up in flames; but I leap over from the window of our stair-well and carry my love, who is lying unconscious on the floor in her nightdress, out through the inferno of smoke and fire.

My heart is beating fit to burst with joy and excitement. So vivid is the imagined scene, that I can feel the touch of her bare arms round my neck as I carry her and the coolness of the unmoving lips I cover with kisses. The image keeps on surging through my blood, as if, with each sweet, bewitching detail, it has entered my life-stream, so that I can never free myself from it. And it makes me happy, for I know that the impression is so deep that it will appear to me tonight in a real, a living dream. But how many hours there are until then!

I lean out of the window and look up at the sky: day refuses to break. A whole long day still separates me from the night. I am almost afraid because the morning must come before the

night, it might destroy all my hopes! The roses might fall off when Ophelia opens her window, and she won't see them at all. Or she will see them and pick them up and ... what then? Will I have the courage not to hide immediately? An icy cold spreads over my body, for I know I will definitely not have the courage. But I comfort myself with the thought that she might guess whom the roses are from.

She must guess! It is impossible that, however mute and shy they are, the passionate, yearning thoughts of love which my heart radiates, should not penetrate hers!

I close my eyes and imagine, as vividly as possible, that I am over there by her bedside, that I lean down and kiss her in her sleep, in the ardent hope that she will dream of me.

I see it all so clearly in my mind's eye that for a while I am unsure whether I have been sleeping or what was happening to me. I had been absentmindedly staring at the three white roses over there on the window-ledge until they dissolved in the morning twilight. Now they have reappeared, but I am tortured by the thought that I stole them from the cemetery. Why did I not steal red ones? They belong to life. I cannot imagine that a dead man, waking up to find red roses missing from his grave, would demand them back.

At last the sun has risen. The space between the two houses is filled with the light from its rays. I feel as if we are hovering high above the clouds, for down below the alley has become invisible, swallowed up by the mist the morning breeze wafts through the streets.

A bright figure is moving in the room across the alley. I hold my breath in apprehension. I clasp the banister-rail with both hands to stop myself running away.

Ophelia!

For a long time I do not dare to look across. A horrible feeling that I have done something unutterably idiotic chokes me. It is as if the splendour of my dreamland has been simply wiped away. I feel that it will never return and that I should throw

myself from the window at once, or do something else dreadful in order to stifle the ridicule which is bound to break out at any moment, if my fears are realised.

I make one last stupid attempt to rescue my self-respect by frantically rubbing at my sleeve, as if there was a dirty mark on it.

Then our eyes meet.

The blood has rushed to Ophelia's face; I can see her delicate white hands trembling as they hold the roses.

We both want to say something and cannot; each can see that the other lacks the confidence.

Another moment and Ophelia has disappeared.

I crouch down on the steps, curling myself up into a tiny ball, and all I am aware of is the blaze of joy inside me, I am beside myself with a joy that is a jubilant hymn of praise

Can it really be?

Ophelia is a young lady. And me? What am I?

But no. She is young like me. In my mind, I see her eyes again, even clearer than they were in the glare of the sunlight. And I read there: she is a child like me. Only a child could look out of such eyes. We are both still children. She does not feel that I am still just a silly little boy.

I know, just as surely as I know a heart beats in my breast that would let itself be torn into a thousand pieces for her sake, that we will meet again today without having to go looking for each other. I know too that, without either having to tell the other, it will be after sunset, in the little garden between our house and the river.

Chapter 5

The Midnight Talk

Just as the out-of-the-way little town girdled by the ever-rolling river lives on in my heart like a tranquil isle, so the memory of a conversation that I overheard one night rises like an island from the restless waves of those youthful days that bear the name of Ophelia.

I had – as I suppose I did hourly at that time – been dreaming of my love, when I heard the Baron open his study door to a visitor. By his voice I recognised the Chaplain. He sometimes came, even at a late hour, for they were old friends and they would talk, usually until long after midnight, over a glass of wine about all sorts of philosophical questions, and I imagine they sometimes discussed my education; in brief, they spoke of things which were of little concern to me.

The Baron refused to let me go to school. He used to say, "Our teachers are like sorcerer's apprentices, who spend all their time deforming the mind, until the heart dies of thirst. When they have accomplished that, they declare their students ready to go out into the world."

For that reason he would only give me books to read that he had carefully selected from his own library after he had questioned me in order to ascertain the state of my thirst for knowledge. But he never tested me to see if I had actually read them.

"You will note the things your spirit wants your memory to retain, because it will also make you enjoy them", was a favourite saying of his. "Schoolmasters, however, are like animal tamers; the latter think it is important for lions to jump through hoops, the former spend all their time getting children to remember that the late lamented Hannibal lost his left eye in the Pontine swamps; the one turns the king of the desert into a circus clown, the other a divine flower into a bunch of parsley."

The two of them must have been holding a similar conver-

sation, for I heard the Chaplain say, "I would be afraid to let a child drift along like a ship without a rudder. I think it would be certain to run aground."

"As if most people don't run aground!" exclaimed the Baron heatedly. "Has someone not run aground, looked at from the higher standpoint of life itself, who, after a youth spent pining behind school windows, becomes, let's say, a lawyer, marries in order to bequeath his bitter lot to his children, then becomes sick and dies? Do you believe it was for that that his soul created the complicated mechanism we call the human body?"

"Where would we end up if everyone thought as you do?" objected the Chaplain.

"In the most blessed, the most beautiful state the human race can attain! Each one of us would grow in a different way, no one would be like anyone else, everyone would be a crystal, would think and feel in different colours and images, would love and hate differently, as the spirit within wants us to. It must have been Satan himself, the enemy of all colourful diversity, who thought up the slogan that all men are equal."

"So you do believe in the Devil, Baron? You usually deny it."

"I believe in the Devil in the same way as I believe in the deadly power of the north wind. But who can point to the place in the universe where cold originates? That is where the Devil must have his throne. Cold spends all its time pursuing warmth, for it wants to become warm itself. The Devil must come to God, icy death to the fire of life; that is the origin of all journeying. They say there is an absolute zero temperature? No one has ever found it yet, and no one ever will, no more than they can ever find absolute magnetic north. Even if you lengthen a bar magnet, or break it in two, the north pole will always be opposite the south pole, in the one case the portion separating the point where the two appear will be longer, in the other shorter, but the two poles will never meet, for that would mean the bar would be a ring and the magnet would no longer be a bar magnet. You may seek the source of either pole in the finite world, but you will always end up on a journey into infinity.

Look at the picture on the wall, Leonardo da Vinci's *Last Supper*. There you can see what I was saying about magnets, as well as about education through the soul, transferred to human beings. The mission of the soul of each of the disciples is indicated symbolically by the position of his hands and fingers. In each one of them the right hand is active, whether it is leaning on the table, the edge of which is divided into sixteen parts, which could indicate the sixteen letters of the ancient Roman alphabet, or joined with the left hand. It is Judas Iscariot alone whose left hand is active, his right hand is closed! John the Evangelist – of whom Jesus said he might tarry till He came, so that a saying went abroad among the disciples that he would not die – has his hands clasped together, which signifies that he is a magnet which is no longer a magnet, he is a ring in eternity, he is no longer journeying.

These finger positions are strange things, they conceal the deepest mysteries of religion. You find them on old statues of gods in the East, but they also reappear in the paintings of almost all the masters of the Middle Ages.

A legend has been handed down in our family that our ancestor, the lamp-bearer Christopher Jöcher, came from the East, bringing with him the secret of using finger gestures to call up the shades of the dead and bend them to his will for all sorts of purposes.

A document which I possess reveals he was a member of an ancient order which in one place calls itself Shi Kiai, that is 'The Dissolution of the Corpse', and in another Kieu Kiai, 'The Dissolution of the Swords'.

This document tells of things which will sound very strange to your ears. With the help of the art of making the hands and fingers spiritually alive, some members of the order disappeared from the grave along with their corpse, and others transformed themselves in the earth into swords.

Do you not see in that, Father, a striking parallel with the Resurrection of Christ? Especially if you relate it to the mysterious hand gestures in pictures and statues from the Middle

Ages and Oriental antiquity?"

I heard the Chaplain becoming restless, walking up and down the room with hurried steps. Then he stopped and spoke in urgent tones:

"All this, my dear Baron, sounds too much like Freemasonry for me, as a Catholic priest, to accept without contradiction. What you call the deadly north wind is, for me, Freemasonry and everything connected with it. I know well – we have spoken about it often enough – that all great painters and artists were united by a common bond, which they called the Guild, and that they declared this unity beyond frontiers by attaching to the figures in their pictures secret signs, usually in the position of the fingers or gestures of the hands, or through the attitude of faces in the clouds, or sometimes through their choice of colours. Often enough the Church, before commissioning pictures of saints, made them solemnly swear to desist from this practice, but they kept on finding ways of circumventing their oath. People hold it against the Church that she says, if not for everyone to hear, that art comes from the Devil. Is that so incomprehensible for a strict Catholic? When it is well known that artists possessed and preserved a mystery that was clearly directed against the Church?

I know of a letter from a great painter of the past to a Spanish friend in which he openly admits the existence of the secret league."

"I know that letter too", the Baron broke in. "In it the painter says – more or less, I cannot remember his exact words – 'Go to such and such a person, a man by the name of X, and go down on thy knees and beg him to give me just one hint of how to proceed further with this mystery. I do not want to remain merely a painter to the end of my life.' And what does that tell us, my dear Chaplain? Nothing more than that the famous artist, however far he had been initiated into the externals, was in reality only a blind man. There is no doubt in my mind that he belonged to the Guild and that he was a Freemason, which, for me, is as much as to say: he was a mere labourer in the brickyard

who was only involved in work on the exterior of the building. You are quite correct when you say that all the architects, painters, sculptors, goldsmiths and engravers of those days were Freemasons. But – and this is the crucial point – they were only acquainted with the external rituals and only understood them in an ethical sense; they were merely tools of that invisible power, which you, as a Catholic, mistakenly think of as the 'Master of the Left Hand'. Tools they were, nothing else, and their sole purpose was to preserve certain mysteries in symbolic form for posterity, until the time shall be ripe. They always came to a halt part of the way along the path, for they kept on hoping that human lips would give them the key that would open the door. They never suspected that it lies in the execution of their art itself; they never understood that art conceals a deeper meaning than merely producing pictures or creating literature, namely to develop within the artist a kind of hyper-sensitivity of perception and sensation, of which the first expression is called a 'right sense of art'. Even an artist alive today, insofar as his profession has opened his senses to the influences of that power, will be able to bring those symbols back to life in his works. There is no need at all for him to learn of them from the lips of a living person, nor to have been received into one or other of the Lodges. On the contrary, there are 'invisible lips' that speak a thousand times more clearly than the tongues of men. What is true art other than scooping up a portion of this eternal abundance?

It is true that there are people who may justifiably bear the title of 'artist', and yet are possessed by a dark force which you, from your standpoint, can certainly designate as the 'Devil'. Their creations resemble the Christians' conception of the Devil's infernal kingdom, down to the last jot and tittle; their works give off the icy breath of the frozen north, which from earliest antiquity has been seen as the home of the demons that hate mankind. The means of expression their art uses are pestilence, death, madness, murder, blood, despair and depravity.

How can we explain this kind of artistic temperament? I will

59

tell you. An artist is a person in whose mind the spiritual, occult side of man has achieved dominance over the material side. That can come about in two ways: on the one hand there are those, let us call them the 'satanic ones', whose brain is beginning to degenerate through excess, through syphilis, through inherited or acquired vices; as a consequence it weighs lighter, so to speak, in the scales, with the result that the spiritual side is automatically made 'heavier and manifest in the world of appearances'. It is only because the other side has become lighter that the pan of the scales with the occult faculties sinks, and not because it has become heavier itself. In such cases the works of art are suffused with a putrid odour. It is as if the spirit were wearing a garment which shone with the phosphorescence of decay.

In the other artists – I like to call them the 'anointed ones' – the spirit has, like St. George, attained mastery over the animal. In them, the pan with the spirit sinks into the world of appearances thanks to its own weight. In such cases the spirit wears the golden garment of the sun.

In both kinds of artist, however, the balance of the scales has been tilted in favour of the occult, whilst in the average person it is the animal alone that has weight; both the 'satanic' artist and the 'anointed' artist are moved by the wind from the invisible realm of eternal abundance, the former by the north wind, the latter by the breath of dawn. The average person, on the other hand, is as unyielding as a solid block of wood.

What is that power that uses the great artists as an instrument to preserve the symbolic rites of magic for those that come after?

I tell you, it is the same power that once created the Church. It builds two living columns at the same time, the one white and the other black; two living columns, which will hate each other until they realise that they both support the same triumphal arch.

Remember the place in the Gospels where St. John says, 'And there are many other things which Jesus did, the which, if

they should be written every one, I suppose that even the world itself could not contain the books that should be written.' Now, Father, how can you explain that, according to your belief, it was the will of God that the Bible came down to us, but not those 'other things'? Have they been 'lost', just as a boy 'loses' his pocket-knife?

I tell you, those 'other things' are still alive, they have always been alive, and will live on, even if all the lips to tell them, and all the ears to hear them, should die. The spirit will keep whispering them into life, and it will create more and more artists, with minds that vibrate when it wills it, and more and more hands, that will write as it commands. Those are the things that St. John knew of and knows of, the mysteries that were with 'Christ', and which he included when he made his instrument, Jesus, say, 'Before Adam was, I am'.

I tell you – whether you cross yourself or not – the Church began with Peter, but will only be completed by John. What does that mean? Try reading the Gospels as if they were a prophecy of what will become of the Church. Perhaps if you look at them from that point of view you will see what it means that Peter denied Christ thrice and was angry when Jesus said of John, 'I will that he tarry till I come.' For your comfort, I will add that though I believe the Church will die – I can see it coming – it will rise from the dead, and it will be as it should be. Nothing, nor any person, not even Jesus Christ, has risen from the dead without dying first.

I know you too well as an honest man who takes his duty very seriously for me to harbour the least doubt that you have often asked yourself how it is that among the clergy, even among the Popes, there could be criminals, men unworthy of their position, unworthy to bear the name of monk? I know, too, that if anyone were to ask you for an explanation of such facts, you would say, 'It is only the office that is free of sin, and not the man who holds the office.' Do not think, my dear friend, that I am one of those who would mock such an explanation, or who think themselves too clever to be taken in by what they see as

a piece of glib hypocrisy. My conception of a priest's mission is too deep for that.

I know well, perhaps even better than you do, just how many Catholic priests there are whose hearts are filled with fearful doubt. 'Can it really be the Christian religion', they ask, 'that is called to redeem mankind? Do not all the signs of the times indicate that the Church is decayed. Will the millennium really come? It is true that Christianity is growing like a huge tree, but where are the fruits? Day by day the number of those that call themselves Christians is increasing, but fewer and fewer are worthy of it!'

Where do these doubts come from, I ask you? From weakness of faith? No. They come from the subconscious recognition that there are too few among the priests whose sense of mission is fiery enough for them to seek the path of sanctification, as the Yogis and Sadhus do in India. There are too few to take heaven by force. Believe me, there are more paths to the resurrection than the Church dreams of. But a lukewarm hope of 'grace' is not one of them! How many are there among your fellow priests who can say of themselves, 'As the hart panteth after the water brooks, so panteth my soul after thee, O God'?

They are all secretly hoping for the fulfilment of the apocryphal prophecy, which says that fifty-two popes will appear, each one bearing a hidden Latin name, which alludes to his work on earth; the last one will be called 'flos florum', that is the 'flower of flowers', and it is under his sway that the millennium will dawn.

I will make you a prophecy – I, who am more of a heathen than a Catholic – that he will be called John and will be a mirror-image of John the Evangelist; from John the Baptist, the patron saint of the Freemasons, who preserve the mysteries of baptism with water without knowing them themselves, he will be given power over the lower world.

Thus will two pillars come to bear a triumphal arch!

But if, today, you were to write a book and say, 'To lead mankind we need neither a soldier nor a diplomat, neither a

professor nor a ... blockhead, but a priest and no one else', its publication would be greeted with a scream of rage. And if you were to go on to write, 'The Church is only one half of a sword that has been broken in twain, and its measures will only be half measures until Christ's representative is at the same time the Vicar of Solomon, the head of the Order', the book will be burnt on a bonfire.

Of course, the truth could not be burnt or crushed. It is becoming more and more manifest, like the inscription over the altar in our St. Mary's Church, where the painted board they put there to cover it up keeps on falling off.

I can tell from your expression that you object to the idea that there might be a sacred mystery belonging to the opponents of the Church that the Catholic Church knows nothing of. Yet that is the case, though with the crucial restriction that those who guard it can make no use of it, their community is the other half of the 'broken sword' and cannot comprehend its meaning. Truly, it would be more than grotesque to imagine that the respectable gentlemen who founded the Gotha Life Insurance Company should possess a magic arcanum for the overcoming of death."

There was a long pause. The two old gentlemen seemed to be lost in thought. Then I heard the clink of glasses, and after a while the Chaplain said, "Where on earth do you get all this strange knowledge from?"

The Baron was silent.

"Or do you not like talking about it?"

The Baron avoided a direct answer, "Hmm. It depends. Some of it is connected with my life, some just came to me and some I ... er ... inherited."

"That one can inherit knowledge is new to me. However, people still tell the oddest stories about your late father."

"What, for example?" said the Baron, a smile on his face. "I would be very interested to hear."

"Well, people say he was ... he was ..."

63

"A fool!" said the Baron genially.

"Not exactly a fool. Oh no, not at all. But an eccentric of the first order. He is supposed – so people say, but you mustn't imagine I believe this kind of talk – he is supposed to have invented a machine to inculcate a belief in miracles in ... well ... in hounds."

"Ha ha ha!" the Baron burst out laughing. He laughed so loud and so long and so heartily that I, in my bed in the next room, found it infectious and had to clench my teeth on my handkerchief so as not to betray to them that I was listening.

"I knew it was all nonsense", the Chaplain apologised.

"Oh!" – the Baron was still gasping for breath – "oh, not at all. It's quite correct. Ha ha! Just a moment please, I must get this laughter out of my system. That's better. You see, my father was a character such as you don't seem to find any more nowadays. He had an immense store of knowledge, and if there was anything the human mind was capable of thinking up, he thought it up. One day he gave me a long look, snapped shut the fat tome he had been reading, threw it to the ground (since that day he never looked into another book) and said to me, 'Bartholomew, my lad, I have now realised that everything is nonsense. The brain is the most superfluous gland we humans possess. We should have it removed, like our tonsils. I have determined to start a new life from today.'

The very next morning he moved into a small castle we owned at that time in the country, and spent the rest of his days there. It was only shortly before his death that he returned home, to die here, peacefully, on the floor below.

Whenever I went to visit him in the castle, he would show me something new. Once it was an enormous, intricate spider's web on the inside of a window-pane, that he looked after as if it were the apple of his eye. 'You see, my son,' he explained, 'in the evening I set a bright light here, behind the web, in order to attract the insects outside. Swarms of them come whizzing along, but they can't get caught in the web because the window is in between. The spider, who naturally has no idea what glass

is – where would it find something like that in the natural world? – cannot understand what is happening, and is probably shaking its head in disbelief. But the fact is that every day it weaves a finer and finer web – without that having any effect on the problem whatsoever! In this way I want to cure the beast of its unhesitating trust in the omnipotence of understanding. Later on, when, through reincarnation, it has become a human being, it will thank me for such far-sighted education, for it will have a subconscious hoard of experience, which can be of great value to it. It is clear to me that when I was a spider, I lacked such an educator, otherwise I would have thrown away my books when I was a child.'

Another time he took me to see a cage full of magpies. He threw masses of food to them, and they all pounced on it greedily and, fearing the others might eat more quickly, stuffed their beaks and crops so full that they could not swallow.

'I am letting these creatures satisfy their greed and selfishness until they are nauseated by it', he explained. 'I hope that in their later lives they will then avoid the barrenness of parsimony, the quality above all others which renders man ugly.'

'Or', I objected, 'they will invent pockets and purses!' At this my father grew thoughtful, then without a word he opened the cage and set the birds free.

'I hope you won't have any objections to this at least', he growled, leading me to a balcony on which stood a ballista, a machine for hurling stones. 'Do you see all those curs in the meadow down there? They lie around all day in ungodly idleness without a care in the world. I'll soon put a stop to that.' He took a pebble and hurled it at one of the dogs, which immediately leapt up in fright and peered round on all sides to see where the missile might have come from; then it gazed up at the sky in bewilderment and padded about restlessly before it settled down again. To judge by its perplexed behaviour, it must quite often have been the victim of such mysterious attacks.

'Used with patience, this machine will unfailingly plant the seed of a future belief in miracles in any hound's heart, however

godless it may be', said my father proudly. 'Don't laugh, presumptuous boy! You name me one calling that is more important. Do you think the way Providence treats us is any different from what I do to these curs?'

So you see, my father was a complete oddity, and yet full of wisdom", the Baron concluded.

They had both had a long laugh, then he continued, "A remarkable destiny is handed down from generation to generation in my family. But do not imagine, even if my words should sound somewhat arrogant, that I consider myself something special, even one of the elect. I do have a mission, it is true, but it is a very modest one, even if for me it is important and one that I hold sacred.

I am the eleventh in the generations of the Jöchers. Our founding father we call the root; we other ten, the Barons, are the branches. All our first names begin with 'B', for example Bartholomew, Benjamin, Balthazar, Benedict and so on. Only the root, our founding father Christopher, has a name beginning with 'C'. In our family chronicle it says that our forefather prophesied that the twelfth branch, the crown of the family tree, would once more be called Christopher. 'It is strange', I often used to think to myself, 'everything he foretold has come true, word for word; only the last seems to be wrong, for I have no children. Then a strange thing happened; I heard about the child in the orphanage, whom I have now adopted, and took him in solely because he walked in his sleep, something which is characteristic of the Jöchers. When I learnt he was called Christopher, it was like an electric shock, which so took my breath away, that I was gasping for air all the way home. In our chronicle the family is compared to a palm-tree, from which a branch falls off to make way for each new one that appears, until finally all that is left will be the root, the crown and the smooth trunk, which will send out no side-shoots, so that the sap can rise freely from the ground to the tree-top. None of my ancestors has had more than one son, and none any daughters at all, so that the palm-tree symbol retains its full force.

I am the last branch and, to cap it all, I live up here under the eaves. I don't know what it was, but I just felt there was something urging me to move to the top of the house. My ancestors never spent more than two generations on the same storey.

Much as I love him, the boy is not my son, of course. That's where the prophecy breaks down. It often makes me feel sad, for I would have liked the crown of the tree to be a shoot from my blood and that of my ancestors. And who can tell how far he will be our spiritual heir? But what is the matter, Chaplain? Why are you staring at me like that?"

From the sound of a chair falling over, I guessed that the Chaplain had jumped up. I was gripped with a burning fever that intensified with every word the Chaplain uttered.

"Baron Jöcher! Hear me out!" he exclaimed. "I was going to tell you the moment I came in, but then I kept putting it off until the conversation took a suitable turn. But once you started your story, I forgot, for the while, my purpose in coming here. I am afraid I am going to open an old wound in your heart ..."

"Go on, go on", the Baron encouraged him.

"Your wife who disappeared ..."

"No, no, she didn't disappear, she ran away. Don't be afraid to say what really happened."

"Well, your wife and the unknown woman whose body was found in the river about fifteen years ago and who is buried in the cemetery, in the grave with the white roses but no name, were one and the same person. But – and here you have true cause for rejoicing, my friend – her child can only be – there is no possible doubt – the foundling, Christopher! You said yourself that your wife was pregnant when she left you. No! No! Do not ask me how I know. I would not tell you, even if I were permitted. Assume someone told me in confession. Someone you do not know –"

That was all that I heard. I was going hot and cold. That midnight talk gave me back both father and mother, as well as sadness at knowing I had stolen three white roses from the grave of the one who had given birth to me.

Chapter 6

Ophelia

The children still trot along behind me as I make my way through the streets, head held high and proud of the honorary office of the Jöchers, especially since I now know that their forefather is also mine. But the mocking chant of "Doo'cot, doo'cot, diddle diddle doo'cot" is getting more and more ragged. Most of the children merely clap their hands to the rhythm or just sing "diddle diddle".

And the grown-ups! They doff their hats in response to my greeting, where before they only used to nod; and when people see me coming from my mother's grave, where I go every day, heads nod and tongues wag behind my back. Word has got around the little town that I am the natural son of Baron Jöcher, and not just an adopted child.

Whenever I meet Frau Aglaia, she curtseys, as if a religious procession were passing, and takes every opportunity of speaking to me and asking me how I am. When she is with Ophelia, I slip out of the way before we meet, to save the pair of us from blushing at the old woman's obsequious manner.

Mutschelknaus, the carpenter, literally freezes whenever he sees me; if he thinks he can get away without being seen, he shoots back into his den like a frightened mouse. I can feel his embarrassment at the fact that it is I, whom he now regards as belonging to another world, who share his midnight secret.

I went to see him in his workshop, just once. I wanted to tell him that he had no reason to be ashamed in front of me. I intended to say how much I respected him for the way he sacrificed himself for his family. I was going to use my father's words, that 'every profession was noble that the soul considered worthy of carrying on after death', and was looking forward to the liberating effect they would have on him. I did not get the chance to deliver my speech, and the very thought of a further

visit is more than I can bear.

He tore a curtain from the window and threw it over the coffin, so that I should not see the rabbits, threw his arms wide, bowed until his trunk was parallel to the ground and remained in this Chinese posture, without looking at me, repeating, over and over again, like a litany, "Your Serene and Honourable Baron Lordship has deigned –"

Eventually I turned tail and ran. The few words I stammered were all wrong. Whatever I tried, it sounded like arrogance, whatever word I managed to bring out, I was 'deigning'. The simplest, plainest language bounced back off his aura of servility, and wounded me, like an arrow whose head had been smeared with the poison of condescension.

Even my silent departure burdened me with the feeling that my behaviour had seemed haughty.

Herr Paris, the 'celebrated' theatre director, is the only one of the grown-ups who has not changed his behaviour towards me. My secret fear of him has increased. He has a paralysing influence, which I am powerless to oppose. I have the feeling that it resides in his bass voice and the loud imperiousness of his manner of speaking. I try to persuade myself that it is a silly idea, and that I don't have to start with fright whenever he shouts at me; and even if I do, what does it matter?

But every time I hear him across the alley, declaiming in Ophelia's room, the deep note of his voice makes me tremble, and I am gripped with a mysterious fear. I feel so small and weak and am ashamed of my high, boy's voice.

I keep telling myself that he has no idea, cannot possibly have any idea, that we are in love, Ophelia and I; I tell myself that he is a stupid play-actor and that the piercing looks he gives me when we meet in the street are nothing more than probes, sounding out the ground; but it is all to no effect, I can repeat it as much as I like, but I cannot free myself from the humiliating feeling that I am under his spell, and that it is nothing but a sham when I occasionally find the courage to look him straight in the eye. It is a coward's fear of himself, and nothing more.

I often wish he would clear his throat in that insolent and challenging manner again, as he did when he saw me coming from the cemetery, so that I would have an excuse to start an argument with him, but he has stopped doing it; he is lying in wait. I assume he is keeping his bass voice in reserve, until the right moment comes, and inside I am all aquiver that, when it comes, I may be unprepared.

Ophelia, too, is in his power, defenceless. I know, although we never talk of it. When we meet at night by the river, in the little garden outside our house, in rapturous embrace, whispering words of love to each other, we start with sudden fright each time we hear the slightest sound near us; and we each know that it is the constant fear of that man that makes the other's hearing so unnaturally keen.

We cannot even bring ourselves to speak his name. Timidly, we skirt round any topic that might lead to it.

There seems to be a curse on me that makes me run into him every evening, whatever time I choose to leave the house. I feel like a bird trapped by a snake that is circling closer and closer round it.

But he appears to sense in our meetings a portent of success; he savours the feeling that every day he is coming closer to his goal, I can tell by the malicious gleam in his tiny, spiteful eyes. But what can that goal be? I do not think he has any clear idea of that, any more than I have. That is his problem, and my comfort. Otherwise, why should he stop and ponder, gnawing at his lower lip, whenever I hurry past?

He no longer fixes me with his gaze. He knows it is not necessary any more. His soul has mine in its power anyway.

He cannot spy on us at night, but still I have thought up a plan to stop us having to live in constant fear of him. At the foot of the wooden bridge is an old boat, half pulled up onto the bank. I went to fetch it today and moored it near our garden. When the moon disappears behind the clouds I will row Ophelia over to the other side, and then we will float downstream, right round

the town. The river is too wide for anyone to see, let alone recognise us.

I have slipped into the room separating my father's bedroom from mine and am counting my heartbeats, hoping that the strokes will soon come from the tower of St. Mary's, ten resounding blows, and then the eleventh, the one that cries in jubilation, 'Now, now Ophelia is coming down to the garden!'

Time seems to stand still, and in my impatience I start to play a curious game with my heart, so that my mind gradually becomes confused, as if in a dream. I try to persuade it to beat faster, so that the clock in the church tower will also go more quickly. It seems quite natural to me that the one should follow the other. Is my heart not a clock as well? asks a questioning thought. And if so, why should it not be more powerful than the one up in the tower, which is only made of lifeless metal and not of living flesh and blood like mine.

Why should it not have the power to make time hurry along?

And as if in confirmation, two lines from a poem my father once read to me suddenly come to mind, "Heart-born and heart-joined, / All things proceed from the heart." Now I can understand the dreadful meaning that resides in those words, that were mere sound to my ears when I first heard them. Now I comprehend them with a meaning that shocks me to the core: the heart within me, my own heart, does not obey when I call to it, 'Beat faster'. Living within me must be one who is stronger than I, one who dictates time and destiny to me.

That is where things must proceed from.

I feel a shock of horror at myself, for suddenly the sense is clear to me, 'I would be a magician and would have mastery over each and every happening, if I only knew myself, if I only had power over my own heart.'

This train of thought is interrupted by another, which appears uncalled, saying, 'Do you remember that passage in the book you read years ago in the orphanage? Did it not say, 'Clocks often stop when someone dies'? This is how it comes about:

with the nightmare of death weighing down on them, the dying mistake the slower and slower beat of their hearts for the tick of a clock. The fear of the body, which is about to be abandoned by the soul, whispers to them, 'When that clock stops ticking, I shall be dead', and, as if by a magic command, the clock stands still with the last heart-beat. If there is a clock in the room of someone the dying person is thinking of, then that will be the one that will blindly follow the words that spring from mortal fear, for the dying are present, like their own doubles, in places they are thinking of at the moment of death.'

So it is fear that my heart obeys! It is more powerful than my heart! If I could banish it, then I would have power over everything that proceeds from the heart, over time and destiny!

I suddenly find myself breathless, fighting against a fear that falls on me, tries to suffocate me, because I am feeling my way towards its lair. I am too weak to master it, for I do not know how or where to grasp it. It attacks my heart instead of me, squeezing it to force it to shape my destiny according to its will and not mine.

I try to calm myself down by telling myself that, as long as I am not with Ophelia, she is in no danger, but I am too weak to follow the dictate of reason and not go down to the garden tonight. No sooner have I accepted the idea, than I reject it.

I can see the snare that my heart is laying for me and yet I walk straight into it. My yearning for Ophelia is stronger than all reason.

I go to the window to collect my thoughts and to find the courage to face up to the danger which I know is inevitable because I can sense my fear of it, but the sight of the inexorable flow of the mute, unfeeling water has such a fearful effect on me that for a moment I miss the thunder of the church clock striking. My mind is numbed by the dim fear that the destiny I can no longer avoid is being borne along by the river

Then I am aroused by the metallic vibrations, wiping away fear and trepidation.

Ophelia!

I can see her white dress shimmering in the garden.

"My dear, my own child, I've been so afraid for you all day."

"And I for you, Ophelia", I am about to say, but she embraces me and her lips close over mine.

"You know, I think this evening is the last time we will see each other, my poor, dear child?"

"Good God, Ophelia, has something happened? Quick, let's get into the boat, we'll be safe there."

"Yes, let's go. Perhaps we'll be safe there, safe from him."

From him! It is the first time she has mentioned 'him'! From the way her hand is trembling I can tell how boundless her fear of 'him' must be. I set off towards the boat, but for a moment she resists, as if she cannot tear herself from the spot. "Come along, Ophelia", I urge, "don't be frightened. We'll be over by the other side in a moment. The mist will veil –"

"I'm not frightened. I just want to ..." she falters.

"What's the matter, Ophelia?" I put my arms around her. "Don't you love me any more?"

"You know how much I love you, Christl, my child", is all she says. There follows a long silence.

"Let's go to the boat now", I urge her again in a whisper. "I want you so much."

Gently, she withdraws from my embrace, takes a step back towards the bench where we always sit, and runs her fingers along it, lost in thought.

"What's the matter, Ophelia? What are you doing? Is there something troubling you? Have I hurt you?"

"I just want to – I just want to say goodbye to the dear old bench. Do you remember when we first kissed here?"

"You're going to leave me?

I almost scream. "Ophelia, in God's name, you can't. Something's happened and you won't tell me! Do you think I could live without you?"

"No, my little child, be still, nothing's happened yet." She softly comforts me and tries to smile, but as the moonlight falls

bright across her face, I can see that her eyes are full of tears. "Come, my love, come; you're right, let's get into the boat."

With every pull on the oars my heart feels lighter; the wider the stretch of water between us and the dark houses with their glowing, spying eyes, the safer we are from danger. Finally the willows along the other bank appear through the mist; the water is shallow and calm, and we drift along slowly beneath the overhanging branches. I have shipped the oars and am sitting next to Ophelia on the rudder seat, locked in a tender embrace.

"Why were you so sad just now, my love? Why did you say you wanted to say farewell to the bench? Tell me you'll never leave me."

"Sometime or other it must be, my own, dear child. And the time is coming nearer. No, no, there's no need to be sad. It might still be a long time. Let's not think about it."

"I know what you are talking about, Ophelia." My eyes are brimming with tears and my throat is burning. "You mean when you will go to the capital to be an actress, and we won't see each other any more. Do you imagine I haven't been thinking of it, dreading it day and night? I am certain I won't be able to bear the separation. But you said yourself that it will be a year before you have to leave?"

"Yes, a year ... at least."

"And by that time I will be sure to have found a reason for going to the capital myself, so that we can be together. I will keep on asking my father, pleading with him until he lets me study there. Then when I have a profession and can support myself, we will get married and never part again ... You're not saying anything, Ophelia, don't you love me any more?" I ask anxiously.

From her silence I can read her thoughts, and they wound me to the heart. She is thinking how much younger than her I am, and that I am building castles in the air. I know that too, but I refuse to ... to think that we might ever have to part. I want us to intoxicate ourselves with the belief that miracles are possible.

"Ophelia, listen –"

"Please, please, don't say anything", she pleads. "Let me dream."

We snuggle up close to each other and sit there for a long time in silence. It is as if the boat were motionless and the steep, white sandy banks were slowly gliding past in the bright moonlight.

Suddenly she gives a start, as if she were awaking from sleep. I give her hand a comforting squeeze, for I think some noise has frightened her. Then she says, "Will you promise me something, Christl?"

I search for words of reassurance, I want to tell her that I would go through torture for her, if it were necessary.

"Will you promise me that you will ... that you will bury me under the seat in the garden, when I am dead?"

"Ophelia!"

"Only you alone may bury me, and only in that spot. Do you hear? No one else must be there, and no one must know where my grave is. Do you hear? I love the old bench so much. Then I will always feel as if I am waiting for you."

"Ophelia, don't say such things! Why are you thinking about death just now? When you die, I will die with you, you know that. Can't you feel –"

She stops me before I can finish. "Christl, my own, don't ask me why, just promise me what I ask."

"I promise, Ophelia, I give you my solemn promise, even if I cannot understand what you mean."

"Thank you, thank you my dear, dear child. Now I know you will keep it."

She presses her cheek against mine, and I can feel her tears falling on my face.

"You're crying, Ophelia. Won't you confide in me, tell me why you are so unhappy? Are they tormenting you at home? Please, please, tell me, Ophelia. I get so miserable when you are silent like this, that I don't know what to do."

"Yes, you're right, I will stop crying. It's so beautiful here,

so quiet, so magically still. I am so unutterably happy that you are with me, my own."

And we kiss, wildly, passionately, until we almost faint with love.

All at once I feel full of a confident optimism about the future. It will surely turn out the way I pictured it to myself during those quiet nights. It must!

"Do you think", I ask, full of a secret jealousy, "you will enjoy being an actress? Do you imagine it will really be so wonderful when people applaud you and throw flowers onto the stage?" I kneel down before her; she has her hands clasped in her lap and is looking thoughtfully out across the surface of the water into the distance.

"I have never thought about how it will be, not even once ... It seems to me repulsive and ugly to stand up in front of people and act out delight or mental torment before them. It will be ugly if it is all feigned, and obscene if I really feel it and then a moment later throw off the mask to accept their thanks as reward. And to do that evening after evening, and always at the same time! I feel that I am being asked to prostitute my soul."

"Then you must not do it!" I exclaim, every muscle taut with determination. "Tomorrow, as soon as it is light, I will speak with my father. I know that he will help you; I'm sure of it! He is so immeasurably good and tender-hearted. He will not allow them to compel you –"

"No, Christl, you will not do that!" she interrupts in a calm, firm voice. "It is not for my mother's sake that I am asking you not to do it; it would destroy all her vain plans, but I don't ... I don't love her. I can't help it, I'm ashamed of her", she continues in low voice, her face turned away from me, "but I love my ... my ... foster-father. Why should I not say openly that he is not my real father? You know, don't you, even though we have never spoken about it? No one told me, but I know; even as a child I felt it, felt it even more clearly than one can know something. He has not the faintest idea that I am not his daugh-

ter. I would be happier if he did know. Then perhaps he would not love me so much and would stop torturing himself to death for my sake.

Oh, you have no idea how often, even as a child, I was close to telling him. But there is a dreadful wall between him and me. It was my mother who raised it. Ever since I can remember I have never been allowed to speak more than a few words with him alone, as a little girl I was never allowed to sit on his knee or kiss him. 'Don't touch him, you'll make yourself dirty', she always used to say. I was always the shining princess and he was the grubby, despised slave. It is a miracle that horrible, poisonous seed has not taken root in my heart. I thank God that He has not allowed it ... Sometimes, on the other hand, I think that if I really had turned into such an unfeeling, arrogant monster, then I would not feel torn apart by this indescribable pity for him, and I rail at destiny for not having let me be like that.

Often I choke on every bite I take at the thought that he has worked till his hands bled to put it on the table. Only yesterday I jumped up from the table and ran down to him. My heart was so full, that I thought that this time I would tell him everything. I wanted to say, 'Drive us from your door like stray dogs, my mother and I, for that is all we are worth. And him, 'him', that cruel, despicable bloodsucker, who is probably my real father! Throttle him! Take your honest carpenter's tools and strike him dead!' I wanted to scream at him, 'Hate me, with a hatred beyond forgiveness', so that I should be finally freed from this terrible, burning pity.

How many thousand times have I prayed to God, 'Send hatred into his heart.' But I think it is more likely that this river should flow back upstream than that his heart should harbour hatred ...

My hand was already on the latch of the workshop door, when I looked in through the window. He was standing at the table, writing my name on it with a piece of chalk. The only word he can write! At that, my resolution left me. For ever.

I know what was bound to happen, if I had gone in to confront

him: either he would not have listened to a word I was saying, but just stood there stammering, "Fräulein Ophelia, my daughter, what an honour!", as he does every time he sees me, or he would have understood and ... and ... gone mad.

You see, my own, that's why you cannot, must not help me.

Could I destroy the only hope he has? Could I be the one to make his mind lose what grip on reality it has? No, there is only one course left open to me: to become that for which he slaves away day and night, a shining star; only, it is true, in his eyes, in my own I will be a spiritual prostitute.

Don't cry, my child, my own dear child, don't cry now. Have I caused you pain? Come here and dry your tears. Would you love me more if I thought differently? I gave you a shock, that's all, dear, dear Christl. Look, perhaps it's not as bad as I portrayed it. Perhaps I'm just being sentimental and seeing everything distorted and out of perspective. If you spend all day declaiming 'Ophelia', then some of it sticks. That is the horrid thing about this wretched acting business, it starts to infect your soul.

Look, perhaps a marvellous miracle will happen and I'll be a resounding failure in the capital, then everything will turn out fine."

She laughed, loud and long, and kissed away my tears, but it was only a pretence she put on to comfort me, and I sensed it too clearly to join in her laughter. Mingled with my deep sadness for her is a feeling that almost crushes me. Sorrowfully I realise that it is not just in years that she is older than me, no, compared with her I am a child. All the time since we have known each other, she has concealed all her grief and torment from me. And I? I have taken every opportunity to pour out my trifling boyish worries to her.

It is as if this cruel recognition, that her soul is older and more mature than mine, were secretly sawing off the roots of all my hopes. She must be feeling something similar, for, however passionate and tender her embrace and her repeated kisses, her caresses suddenly seem to me to be those of a mother.

My lips pour out all the ardent words I can think of, but the wildest, most reckless thoughts are racing round my mind. 'There must be something I can do! Deeds alone can make me her equal. How can I help her? How can I save her?'

I feel an awful, black shadow rising up within me, a shapeless something reaching for my heart; I hear the whisper of a hundred hissing voices in my ear, 'Her father, that moronic carpenter, is the barrier! Tear it down! Get rid of him. Who will see it? What are you afraid of, you coward?'

Ophelia lets go of my hand. She shivers. I can see that it is a shudder of fear.

Has she guessed my thoughts? I wait for her to say something, anything that will give me a hint as to what I should do. Everything inside me is waiting: my mind, my heart and my blood; the whispers in my ear have stopped and are waiting, waiting and listening in expectation of victory.

Then she says – I can hear her teeth chattering with inner cold, and she murmurs as much as she speaks, "Perhaps the Angel of Death will have mercy on him."

The black shadow within me suddenly flares up into a terrible white blaze, filling me from head to foot. I jump up and grasp the oars. As if it is the sign it had been waiting for, the boat accelerates of its own accord, and we shoot out into midstream, towards the bank where Baker's Row runs.

The glowing eyes of the houses are shining out into the darkness once more.

The swift current is sweeping us towards the weir where it leaves the town. I row for all I am worth across it towards our house, white foam creaming along the sides of the boat.

Every stroke strengthens my wild determination. The leather straps in the rowlocks creak a rhythmical, 'Murder, murder, murder'.

Then I am making fast at a post on the embankment and lifting Ophelia out of the boat. She seems light as a feather in my arms. The feeling that, at a stroke, I have become a man in body and soul fills me with an unbounded, animal joy; quickly I carry

Ophelia past the light of the lamp into the darkness of the alley-way.

We stay there for a long time, embracing each other in an all-consuming rage of passion. She is no longer a tender mother, once more she is my lover.

A noise behind us! I ignore it; what is it to me?!

Then she has vanished into the doorway of the house.

The light is still on in the carpenter's workshop. There is a gleam from the dusty window-panes; the lathe is humming.

I put my hand on the latch and cautiously push it down. A thin pencil of light shines and then disappears as I softly close the door again. I creep up to the window to see where the old man is. He is bent over the lathe, holding a glittering steel chisel in his hand; white, paper-thin wood shavings curl up between his fingers and drop into the murk of the room, piling up round the coffin like so many dead snakes.

I suddenly feel weak at the knees. I can hear my breath whistling in my throat. I have to lean against the wall to stop myself from falling forward through the glass of the window.

'Can I really become a murderer?' The piteous cry tears at my breast. 'Can I fall on him from behind and strike him dead, this poor, old man who has worn himself out in the service of my Ophelia?'

Then: a jolt, and the lathe is still. The humming stops. A sudden deathly hush snaps at my throat.

Mutschelknaus has straightened up; his head on one side, he seems to be listening. Then he puts the chisel down and comes, hesitantly, over toward the window. Closer and closer. His eyes fixed on mine.

I know that he cannot see me as I am standing in darkness and he is in the light; but even if I knew that he could see me, I would still be unable to flee, for all the strength has drained out of me.

He has slowly come right up to the window and is staring out into the blackness. There is only a hand's-breadth between our eyes, and I can see every wrinkle in his face. It has an expression

of boundless exhaustion. Then he passes his hand slowly over his forehead and looks at his fingers, half in astonishment, half musing, as if he had seen blood on them and did not know how it came to be there.

Suddenly his features are suffused with a faint ray of hope and joy, and he bows his head, patient and resigned, like a martyr awaiting the death-blow.

I can understand what his spirit is saying to me!

His dull wits do not know why they let him do all this. His body is merely the outward expression of his soul, which is whispering, 'Release me for the sake of my dear daughter.'

Now I realise that it must be. It is merciful death itself that will guide my hand. Can my love for Ophelia be less than his? Only now do I feel, in the deepest recesses of my soul, what Ophelia has to suffer daily, eaten away by the torment of her pity for him, the most pitiful of all the wretched. It burns into me, like the shirt of Nessus.

Will I be able to carry out the deed? It is impossible for me to imagine it.

Could I smash his skull with that cold chisel there?

Could I look into his dying eyes?

Could I drag his body out into the alley and throw it into the water? And then, my hands soiled with blood for the rest of my life, could I ever embrace Ophelia and kiss her again?

Could I, a murderer, look my dear, dear father in the face, that kindly face?

No! I would never be able to do that, I can feel it. The dreadful deed must be done, and I must carry it out, that I know, but I will sink to the bottom of the river with the dead body.

I pull myself together and slip over to the door. There I pause, before I grasp the latch, and clench my hands together as I try to scream a plea to my heart, 'Lord, who has mercy on us all, give me strength.'

But these are not the words my lips pray. My spirit cannot command them, and they whisper, "Lord, if it be possible, let this cup pass from me."

Then the deathly hush is shattered by a reverberation of brass, tearing the words from my lips. The air quivers, the earth trembles. The clock in the tower of St. Mary's has bellowed out.

In all the life around and within me, it is as if the darkness has turned white.

And, as if from the far, far distance, from the mountain that I know from my dream, I hear the voice of the White Dominican, who confirmed me and forgave me my sins – my past as well as my future sins – calling my name:

"Christopher, Christopher!"

A heavy hand lands on my shoulder.

"Murder most foul!"

I realise it is the grumbling bass voce of Herr Paris, the actor, that is echoing in my ear, soft and muted, full of menace and hatred, but I do not resist. Unresisting, I let myself be dragged into the lamplight.

"Murder most foul!"

I can see him foaming at the mouth. His swollen toper's nose, his flabby cheeks, his chin, gleaming with spittle, everything about him is bobbing with triumph and devilish delight.

"Mur–der–most–foul!"

He has grabbed me by the chest and shakes me at every syllable like a bundle of empty clothes.

It does not occur to me to resist him, or to tear myself free and run away. I have become as weak as some tiny creature at the end of its tether.

He interprets it as guilt, I can see by his expression, but how could I utter even one word? My tongue is limp. Even if I wanted to, I could not describe to him the devastating experience I have just been through.

He keeps shouting at me, then barking hoarsely in my ear, like a madman, foaming at the mouth, clenching his fists in front of my face; I can hear and see it all, but it has no effect on me, I am paralysed, hypnotised. I realise that he knows everything, that he saw us get out of the boat, saw us kissing, that he

has guessed I was going to kill old Mutschelknaus, "in order to rob him" as he keeps on shouting.

I do not defend myself. I am not even shocked to find he knows our secret.

I am like a bird that has forgotten its fear in the jaws of the snake.

Chapter 7

The Cinnabar Book

Fever is hammering at my temples; the boundary between the inside and outside world is as blurred as that between the sea and the sky. I am drifting helplessly on the surging breakers of my blood, now torn down into yawning funnels filled with the blackness of deepest unconsciousness, now floating in a blinding light, flung upwards towards a white-hot sun that scorches my senses.

A hand is holding mine tight. When my eye lets go of it and, tired of counting the myriad tiny holes in the lace cuff from which it protrudes, makes its way up the sleeve, I have a hazy sense that it is my father who is sitting at my bedside.

Or is it only a dream?

I can no longer distinguish between waking reality and my imaginings, but whenever I feel his eye resting upon me, a tormenting sense of guilt forces me to close my lids.

How has it all come about? I can no longer remember. The thread of memory has torn at the point when the actor was shouting at me.

There is only one thing I am clear about: at some time, somewhere by the light of a lamp, I wrote out a promissory note at his order and signed it with my father's forged signature. The writing was so like his that, as I stared at the paper before Herr Paris folded it up and put it away, I thought for a moment my father had signed it with his own hand.

Why did I do it? It seemed such a natural thing to do that even now, with the memory of the deed tormenting me, I cannot wish it undone.

Is it only one night that has passed since then or a whole generation?

I feel as if the actor had vented his spleen on me for a whole year of my life without ceasing. Then, finally, my lack of resis-

tance must have made him realise there was no point in continuing his rage; somehow he must have convinced me that I could save Ophelia by forging the signature.

The only ray of light penetrating my feverish torment is that I am certain I did not do it to save myself from the suspicion of intent to murder.

How I managed to make my way home, whether it was already light or still dark, is a complete mystery to me.

I have a vague picture of myself sitting by a grave, weeping in desperation, and from the scent of roses that flows over me whenever I think of it, I almost believe it was my mother's grave.

Or does it come from the bouquet of flowers there, on the counterpane?

Who can have laid it there?

'My God! I must go and put out the street-lamps!' The thought is like a whiplash on every nerve-end. 'Is it bright daylight already?' I try to jump out of bed, but I am so weak I cannot move a muscle.

Wearily I sink back into the pillows.

'No, it's still night-time', is the thought that comforts me, for my eyes are suddenly plunged back into deepest darkness.

But immediately afterwards I can see the brightness again and the rays of the sun playing on the white wall. And once again I am overwhelmed by the idea that I am neglecting my duty.

I tell myself it is a wave of fever sweeping me back into the sea of delirium; but I am powerless to stop a familiar, rhythmical hand-clapping rising, like something from the dream world, and beating, ever louder, ever clearer, against my ear. Night and day alternate in time with the rhythm, faster and faster, night and day without any transition, and I have to run, run, to be in time to light the lamps, put them out, light them, put them out.

Time is rushing after my heart, trying to catch it, but it manages to keep its pulse one step ahead.

'Now, now I am going to sink beneath the tide of blood', I feel. 'It is flowing from a wound in old Mutschelknaus' head, pouring out between his fingers like a torrent as he clutches at it with his hand. Any second now I will drown in it.' At the last moment I grasp a post that is fixed into the embankment, and hold on tight. As consciousness recedes, I clench my teeth in response to my one remaining thought, 'Keep a firm hold on your tongue, otherwise in your delirium it will reveal that you forged your father's signature.'

Suddenly I am more awake than ever I was by day, more alive than ever in a dream. My hearing is so sharp that I can hear the faintest sound, whether near or far.

Far, far above in the treetops on the other bank the birds are singing, and I can clearly hear voices murmuring their prayers in St. Mary's.

Can it be Sunday?

Strange that the usual roar of the organ cannot swallow up the whispering in the pews. Strange that this time the loud noises cannot harm the soft, weak ones.

What are those doors banging in the house? I thought the other floors were uninhabited? That the rooms below were filled with nothing but dusty old junk?

Is it our ancestors who have suddenly come to life?

I decide to go down. Why shouldn't I, I feel so fresh and full of vigour? Immediately I remember: to do that I would have to take my body with me and that is the difficulty; I can't go down in the broad daylight to pay a visit to my ancestors in my nightshirt.

Then there is a knock at the door. My father goes over, opens it a little and says through the crack in respectful tones, "No, grandpapa, it's not time yet. As you know, you can only come to him when I have died."

This is repeated nine times in all.

When it is repeated the tenth time, then I know that it is our Founding Father outside. I know that I am right by the deep,

respectful bow my father makes as he opens the door wide.

He goes out, and by the slow, heavy tread, accompanied by the tapping of a stick, I can hear that someone is coming to my bed.

I cannot see him, for I have my eyes shut. There is an inner feeling which tells me I must not open them. But through my lids, as clearly as if they were of glass, I can see my room and all the objects in it.

Our Founding Father pulls back the covers and places his right hand on my neck, the thumb sticking out at right angles to make it like a set-square.

He speaks in a monotone, like a priest saying the litany, "This is the storey on which your grandfather died and awaits the resurrection. The human frame is the house in which one's dead ancestors live.

In some people's houses, in some people's bodies, the dead awake, before the time is ripe for their resurrection, to a brief, spectral life. Then the rumours fly of 'haunting', then the common herd talks of 'possession'."

He repeats the process, placing the palm of his hand with the thumb outspread on my chest. "And here your great-grand-father lies entombed."

And so it continues, down the whole of my body, over stomach, loins, thighs and knees, to the soles of my feet. When he places his hands on them, he says, "And this is where I live. For the feet are the foundations on which the house rests; they are the root joining the body of your person to Mother Earth, whenever you walk.

Today is the day following the night of your solstice. This is the day when the dead within you begin their resurrection.

And I am the first."

I hear him sit down by my bed and from the rustle of pages being turned from time to time I guess that he is reading to me from the family chronicle, which my father mentions so often.

It comes to me in the tone of a litany, which lulls my outward senses but excites my inner ones to increasing, sometimes

almost unbearable wakefulness:

"You are the twelfth, I was the first. We start counting with 'one' and we stop counting with 'twelve'. That is the secret of God's incarnation.

You are to become the top of the tree which sees the living light; I am the root, which sends up the forces of darkness into the light.

But you will be I and I will be you when the growth of the tree is complete.

The elder is the tree that in Paradise was called the tree of life. Even today legend has it that it possesses magic power. Cut off its top, its branches and its roots, plant it upside down in the earth, and lo! what was the crown of the tree will become a root, what was a root will put out branches, so completely is each of its cells imbued with the communion of 'I' and 'you'.

That is why I have put it as a symbol on the coat of arms of our family. That is why it is growing as an emblem on the roof of our house.

Here on earth it is only a token, just as all forms are only tokens, but in the incorruptible realm it is the first among all trees.

Sometimes in the course of your wanderings, both here and on the other side, you have felt old: that was I, the foundation, the root, the Founding Father, that you could feel within you. We are both called Christopher, for you and I are one and the same.

I was a foundling, just as you were; but in the course of my wanderings, I found the great father and the great mother, losing the little father and the little mother; you have found the little father and the little mother, but not yet the great father and the great mother.

Thus I am the beginning and you are the end; when each has penetrated the other, then shall the ring of eternity be closed for our family. The night of your solstice is the day of my resurrection. As you become old, so I will become young, the poorer you become, the richer I will be ...

Whenever you opened your eyes, I had to close mine, if you closed yours, then I could see; thus it was until now. We stood facing each other like waking and sleep, like life and death, and could only meet on the bridge of dreams.

Soon all that will be changed. The time is approaching: the time of your poverty, the time of my wealth.

The night of the solstice was the watershed.

Anyone who is not ripe will sleep through it, or will wander the earth, lost in darkness; his founding father must lie entombed within him until Judgment Day.

There are those – they are the presumptuous ones – who believe in their body alone, and commit sins for their own advantage, the ignoble, the ones who despise their family tree; the others are those who, for the sake of an easy conscience, are too cowardly to commit a sin.

But you are of noble blood, and were willing to commit murder for the sake of love.

Doing good and doing evil must become the same, otherwise both will remain a burden, and one who bears a burden can never be a Freeman.

The Master whom they call the White Dominican has forgiven you all your sins, even your future ones, because he knew how everything would come to pass; but you deluded yourself into thinking it was in your power to commit a particular deed or not. He is, from time immemorial, free from both good and evil and therefore free from all delusion. But those, like you or I, who still delude themselves, load this burden or that on themselves.

We can only free ourselves from it after the manner of which I have told you.

He is the great crown of the tree that is to come, arising from the great source-root.

He is the garden; you and I and others of our kind are the trees that grow within it.

He is the great wanderer and we the lesser.

He descends from eternity to infinity; our path takes us from

infinity up into eternity.

Anyone who has crossed the watershed has become a link in a chain, in a chain formed from invisible hands that never let each other go until the end of days. From that point on they belong to a community in which each one has a mission which is destined for him alone.

There are not even two among them who are alike, just as among the human animals on earth there are no two who share the same destiny.

Our whole earth is imbued with the spirit of this community; it is ever-present at all times, it is the living spirit in the great elder tree. It is the origin of all religions of all peoples and ages; they change, but it is unchanging.

Anyone who has become a crown and consciously bears within him the source-root, consciously enters into the community through the experience of the mystery that is called the 'Dissolution with Corpse and Sword'.

In ancient China thousands upon thousands were initiated into this secret process, but only meagre reports have come down to us. Hear now some of them:

"There are certain transformations called *Shi Kiai*, that is the Dissolution of the Corpses, and others called *Kieu Kiai*, that is the Dissolution of the Swords. The Dissolution of the Corpses is the condition in which the form of the dead man becomes invisible and he himself reaches the rank of an immortal. In some cases, the body merely loses weight, or retains the outward appearance of a living man.

In the Dissolution of the Swords, a sword is left behind in the coffin in place of the corpse. These are the invincible weapons, destined for the last great battle.

Both dissolutions are an art which those who have advanced along the path communicate to the favoured among the younger followers."

The tradition from the Book of the Sword, quoted above, says:

"In the method of the Dissolution of the Corpses it comes

90

about that one dies and then comes to life again. It comes about that the head is chopped off and appears from one side. It comes about that the body is present, but the bones are missing.

The highest among the Dissolved receive, but do not act; the rest dissolve in broad daylight with their corpses. Their achievement is to become flying immortals. If they want, they can sink into dry ground in broad daylight.

One of these was a native of Hui-nan and was called Tung Chung Kiu. In his youth he practised inhaling spiritual air and thus purified his body. He was unjustly accused of a crime and was tied up in prison. His corpse dissolved and disappeared.

Liu Ping Hu has no name and no boy's name. Towards the end of the days of Han he was the Elder of Ping-hu in Kieu-Kiang. He practised the art of medicine and came to the aid of his fellows in their illnesses and sorrows as if they were his own illnesses. Journeying on foot, he met the immortal Chu Ching Shi, who revealed to him the path of hidden existence. Later he dissolved with the corpse and disappeared."

I could tell from the rustling of the pages that our ancestor passed over several pages before he continued:

"Whoever possesses the Cinnabar-red Book, the plant of immortality, the awakening of the spiritual breath, and the secret of bringing the right hand to life, will dissolve with the corpse.

I have read to you examples of people who have dissolved, so that your faith will be strengthened through hearing that there were others before you who achieved it. It is to the same end that the Christians' Book tells of the resurrection of Jesus of Nazareth.

Now, however, I will tell you of the secret of the hand, the secret of the breath and of reading the Cinnabar Book.

It is called the Cinnabar Book because, according to ancient belief in China, that red is the colour of the garments of those who have reached the highest stage of perfection and stayed behind on earth for the salvation of mankind.

Just as we cannot comprehend the meaning of a book if we

just hold it in our hand or turn the pages without reading, so we will not profit from the course of our destiny if we do not grasp its meaning. Events follow each other like the pages of a book that are turned by Death; all we know is that they appear and disappear, and that with the last one the book ends. We do not even know that it keeps being opened, again and again, until we finally learn to read. And as long as we cannot read, life is for us a worthless game in which joy and sorrow mingle. When, however, we finally begin to understand its living language, then our spirit will open its eyes, and will start to read, and will breathe with us.

This is the first stage on the path to the Dissolution of the Corpse, for the body is nothing other than congealed spirit; it dissolves when the spirit begins to awaken, just as ice melts in water when it begins to boil.

Everyone has a book of destiny, which is meaningful at the root, but the letters in it will dance around in a confused jumble for those who do not take the trouble to read them calmly, one after the other, just as they are written. Such people are the hasty, the greedy, the ambitious ones, those who use duty as a pretext, those who are poisoned by the delusion that they can mould their destiny to a different shape than the one Death has written in their book.

But anyone who can ignore the idle turning back and forth of the pages, who is moved neither to tears nor to joy but who, like an attentive reader, concentrates his mind on understanding it word by word, will find a higher and higher book of destiny opened for him, until he is one of the elect, for whom the Cinnabar Book, that contains all secrets, lies before him.

That is the only way to escape from the dungeon of fate. Any other attempt is merely a vain, tormented wriggling in the snares of Death.

The poorest in life are those who have forgotten that there is a freedom beyond the dungeon cell, those who, like birds that have been born in a cage, are content with a full feeding bowl and have forgotten how to fly. For them there can be no release.

Our hope is that the great white wanderer, who is on his way down into infinity, will succeed in breaking their bonds.

But they will never look on the Cinnabar Book.

Those for whom it is opened will leave no corpse behind in a higher sense as well; they will drag a lump of earth into the spiritual realm and dissolve it there.

Thus they will take part in the great task of divine alchemy; they will transform lead into gold and infinity into eternity.

Hear now of the secret of spiritual breath.

It is stored up in the Cinnabar Book, but only for those who are root or crown; the 'branches' have no part in it, for if they were to understand it, they would wither on the spot and fall from the trunk. The great spiritual breath does, indeed, flow through them – for how could even the smallest being live without it? – but it passes through them like a wind that sets them in motion but does not stop.

Physical breath is only its counterpart in the external world.

Within us, however, it must settle, until it has become a shining light, penetrating every mesh of the net of our body and uniting with the great light.

How that is to happen, no one can teach you, it is rooted in the most delicate area of our sensibility.

It says in the Cinnabar Book, "Here lies hidden the key to all magic. The body can do nothing, the spirit can do everything. Put away everything that is body, and when your self, your 'I', is completely naked, it will start to breathe as a pure spirit.

One will begin after this fashion and another after that, according to the belief into which he was born; the one through an ardent longing for the spirit, the other by persevering in the certainty that he was born of the spirit and only his body is of the earth.

Anyone who has no religion but believes in the tradition, must accompany all the labours of his hands, even the least, with this constant thought, 'I am doing this for the sole purpose that the spiritual essence within me shall begin to breathe.' Just as the body transforms the earthly air you have inhaled, without

your being able to see the secret place of its labours, so does the spirit, in an incomprehensible way, weave with its breath a royal garment of purple for you: the cloak of perfection.

Gradually the spirit will penetrate your whole body in a deeper sense than with those humans who remain in the animal state. Anywhere its breath reaches, the limbs will be renewed, to serve a different purpose than before.

Then you will be able to direct the current of this breath as you wish. You will be able to drive the Jordan backwards, as it says in the Bible. You can make the heart in your body stand still, you can make it beat slowly or quickly and thus determine the fate of your body yourself. From this time on, the Book of Death will not apply to you.

Every art has its laws, every coronation its splendour, every mass its rite, and everything that is born and grows has its own course.

The right hand is the first limb of the new body that you should wake with that breath.

There are two sounds that are heard first, when the breath meets flesh and blood: the sounds of creation, I and A.

I is 'ignis', that is fire, and A is 'aqua', that is water.

Nothing is made that is not made of fire and water.

When the breath touches the index finger it becomes rigid and resembles the letter I; "the bone calcines" as it says in the sources.

If the breath touches the thumb, than that will become rigid, stick out at an angle and form, with the index, the letter A.

Then "streams of living water will go from your hands", as it says in the sources.

If a person were to die in this state of spiritual rebirth, then his right hand would no longer be subject to the corruption of the flesh.

If you place the awakened hand at your neck, then the 'living water' will pour into your body.

If you were to die in that state, your whole body would be incorruptible, like the corpse of a Christian saint.

But you are to dissolve with your corpse!

That comes about through the boiling of the 'water', which itself is brought about through the 'fire', for every process, even the spiritual process of rebirth, must have its own proper order.

I will bring it about in you before I go from you this time."

I heard the Founding Father close the book.

He stood up and again, just as he had the first time, placed his hand, stretched out like a set-square, at my throat. I felt a sensation of ice-cold water running down through my body to the soles of my feet.

"When I bring it to the boil, the fever will awake within you and you will lose consciousness", he said, "so hear me before your ear grows deaf.

What I am doing to you, you are doing yourself, for I am you and you are I. No other could do to you what I am doing; you could not do it to yourself alone. I must be present, for without me you are only half an 'I', just as I am only half an 'I' without you.

In this way the secret of its accomplishment is guarded from misuse by humans who remain in the animal state."

I felt the Founding Father slowly remove his thumb; then he passed his index finger quickly from left to right across my neck, as if he wanted to cut my throat.

A dreadful, shrill sound like an 'I' scorched through flesh and bone. I felt as if flames were shooting up from my body.

"Do not forget: everything that happens, and everything you do and suffer, you must bear for the sake of the Dissolution of the Corpse." I heard the voice of my forebear Christopher for one last time; it sounded as if it were coming up out of the earth.

Then my last scrap of consciousness burnt to ashes in the blazing fever.

Chapter 8

Ophelia

I am still so weak that my knees tremble when I walk round the room, but hour by hour I can feel ever more clearly that my health is returning.

I am devoured by longing for Ophelia and I would love to go down the stairs to peer into her window and try to catch a glimpse of her. She came to see me when I was unconscious with fever, my father told me, and brought me a bunch of roses.

I can tell by his look that he has guessed everything. Perhaps she has even admitted it to him? I am afraid to ask, and he shyly avoids the topic as well.

He tends me with loving care; the least thing I need, he brings me; but at every token of his affection, my heart pounds with shame and sorrow when I think of the crime I have committed against him. I wish the forging of his signature were nothing but a feverish dream! But now that my mind has cleared, I know all too well that it really happened. Why did I do it? What did I think it would achieve? All the details have been erased from my memory.

I am not going to dwell on it. My only thought is that somehow I must expiate the deed; I must earn money, money and more money, to buy back the note. My forehead is bathed in sweat at the thought. It will be impossible; how should I earn money, here in our little town? Perhaps it would be possible in the capital? No one knows me there. If I offered my services as a servant to some rich man? I would be prepared to work like a slave, day and night.

But how can I ask my father to let me go to university in the capital? What reason could I use, given the number of times he has told me how he hates all learning that has been acquired from books instead of from life itself? Anyway, I lack the required knowledge, or at least a school-leaving certificate.

No, no, it is impossible!

My torment is doubled at the thought that I will be separated from Ophelia for years and years, perhaps even for ever. At that awful thought I can feel the fever start to rise within me again.

I have been ill in bed for two whole weeks. Ophelia's roses are already withered in the vase. Perhaps she has already left? My hands are wet with perspiration as despair takes hold of me. Perhaps the flowers were her farewell to me?

My father can tell how much I am suffering, but he does not ask the reason, not even once. Does he know more than he is willing to say? If only I could pour out my heart to him and confess everything, everything! But no, it cannot be. If he were to cast me off, how gladly I would accept it, that would be an expiation of my guilt. But I know that it would break his heart if he were to learn that I, his only child that he found through a stroke of fate, have behaved like a criminal towards him. No, no, it must not happen!

The whole world can learn about it and point the finger at me for all I care; he alone must never know.

He gently strokes my forehead with a look of love and tenderness in his eyes, and says, "Do not look so horrified, my dear son. Whatever it is that is tormenting you, forget it. Think of it as a feverish dream. You will soon be healthy and happy again."

He hesitates as he says the word 'happy', and I feel that he senses that the days, months, years to come will bring me much pain and misery.

Just as I can sense it.

Does that mean Ophelia has gone already? Does he know?

The question is on the tip of my tongue, but I force it back. I think I would break down in tears if he were to say 'yes'.

He suddenly starts talking, very quickly, the words come tumbling out; he talks about all sorts of things in order to distract me, to turn my mind to other thoughts. I cannot remember having told him of the dream visit – or whatever it was – of our Founding Father, but I must have. Otherwise how could he suddenly start on the same subject? Almost without introduc-

tion, he says:

"You cannot avoid sorrows as long as you are not a 'Dissolved One'. Someone who is still bound to the earth cannot erase what is in the Book of Destiny. What is sad is not that so many people suffer, what is sad is that their suffering serves no higher purpose. That turns it into a punishment for deeds of hate committed in the past, perhaps in an earlier existence. We can only escape this terrible law of reward and punishment if we accept everything that happens with the thought that its purpose is to awaken our spiritual life. Everything we do should be done from this perspective alone. The spiritual attitude is everything, the deed itself nothing! Suffering becomes meaningful and fruitful if you see it in such a light. Believe me, you will not only be able to bear it more easily, it will also pass more quickly and, in some circumstances, turn into the opposite. The things that sometimes happen in suchlike cases are close to the miraculous, and it is not only inner transformations that come about; no, our material destiny can also change in the strangest way. Of course unbelievers laugh at such claims, but then, what would they not laugh at?

It is as if the soul will not allow us to suffer more for its sake than we can bear."

"What actually is to be understood by 'bringing the right hand to life'?" I ask. "Is it merely the beginning of a spiritual development, or has it some other purpose?"

My father thinks for a while.

"How can I make you understand? We can't keep talking in parables.

Like all forms, the limbs of our body are only symbols for spiritual concepts. The right hand is, so to speak, the symbol for action, doing. If, then, the hand takes on spiritual life, that means we have become spiritually active on the other side, whereas until then we were asleep. It is similar with 'speaking', 'writing' and 'reading'. Talking, speaking is, in earthly terms, to communicate. Whether the person with whom we communicate acts on it, is up to him. With 'spiritual' speaking it is dif-

ferent. It is no longer communication, for who is there we would communicate with? 'I' and 'you' are the same over there.

'Speaking' in the spiritual sense is the equivalent of creating, a magical calling up into the world of appearances. Here on earth, 'writing' is the transient setting down of a thought; over there 'writing' is to carve something on the memory of eternity. 'Reading' here means to absorb the sense of a written document; over there it is to recognise the great, unchanging laws – and to act according to them for the sake of harmony. But I think, my lad, that while you are still so weak we should not be talking about things that are so difficult to understand."

"Won't you tell me about my mother, father? What was she called? I know nothing at all of her." The question suddenly appeared on my lips; only when it is too late do I notice that I have touched a wound in his heart.

He paces restlessly up and down the room; his speech is disjointed.

"My dearest son, spare me the pain of having to bring the past back to life. She loved me. Yes, I am sure of that. And I loved her – more than I can ever say.

In this I fared the same as all my ancestors. For the men of the line of Jöcher, anything connected with 'woman' was ever a torment and our undoing. Without it being our fault, without it being the fault of our mothers.

None of us, as perhaps you know, has had more than one son. The marriage never lasted beyond that. It is as if, with that, it had fulfilled its purpose.

Not one of us had a happy marriage. Perhaps it was because our wives were either much too young, like mine, or older than us. There was no physical harmony between us. With each passing year time tore us farther apart. – And why did she leave me? If only I knew! But I ... I do not want to know!

Did she perhaps deceive me? No! I would have felt it. Would still feel it. My sole belief is that love for another woke within her; and when she realised she could no longer avoid her fate, that she was about to be unfaithful to me, she preferred to leave

99

me and seek death."

"But why did she abandon me, father?"

"For that I have only one explanation. She was a strict Catholic and, although she never said a single word on the matter, she considered our spiritual path a devilish aberration. She wanted to keep you from it, and that was only possible by keeping you away from my influence. That you are my true son you must never doubt, do you hear! She would never, never have given you the name Christopher. That alone is an infallible sign for me that you are not the child ... of another."

"Father, tell me just one more thing. What was she called? I would like to know her Christian name when I think of her."

"She was called" – my father's voice gave out, as if the word had stuck in this throat – "she was called ... her name was ... Ophelia."

At last I am allowed out again. I am not to light the lamps any more, my father said, not even later on.

I do not know the reason.

The beadle will see to it, as he did before me.

The first place I go – with heart aquiver! – is down to the window on the stairs, but in the house opposite the curtains stay closed all the time.

After a long, long wait in the alleyway I meet the old woman who looks after the house and ask her what has happened. All my vague forebodings and fears have become reality: Ophelia has left me! The old woman says Herr Paris has left for the capital with her.

Now I can also remember why I signed the promissory note; my memory has returned. He promised me he would not make her appear on stage if I could supply him with money. Three days later he broke his word!

Every hour that passes sees me making my way down to the garden seat. I delude myself into believing that Ophelia is sitting there, waiting for me; she is just hiding so that she can leap out with a cry of joy and rush into my arms.

Sometimes I catch myself behaving oddly: I start turning over the sand around the seat with the spade that is leant against the garden fence, with a stick, with the remains of a plank, with anything that happens to come to hand, sometimes even with my bare hands

It is as if the earth concealed something that I must tear from its grasp.

I have read in books that people who are lost in the desert and dying of thirst root round in the sand in the same way and dig great holes with their fingers.

The pain is burning with such a heat, that I can feel it no more. Or am I hovering above myself, so that the torment cannot reach me?

The capital is many miles upstream; will the river not bring me greetings?

Then I suddenly find myself sitting at my mother's grave, not knowing how I came to get there.

It must be that same name, 'Ophelia', that drew me there.

Why is the postman crossing Baker's Row and going towards our house, now, in the midday heat when everything is sleeping? I have never seen him here before. There is no one who lives round here to whom he might bring a letter.

He sees me, stops and rummages round in his leather bag.

I know my heart will burst if it is a message from Ophelia!

I stand there, dazed, holding in my hand something white with a red seal.

"Dear Baron Jöcher,
If you should open this letter to Christopher, then please, please, do not read any further. I beg you, from the depths of my soul, do not read the accompanying pages. If you are unwilling to pass the letter on to Christl, then burn both of them, but whatever you do, do not let Christl out of your eyes, not for one minute. He is still so young, and I would not like to be the reason for him committing a rash act, if he were to learn from other lips

than yours what you – and he – are bound to learn soon.

Please fulfil this request that comes from the bottom of my heart (I know that you will).

Your most obedient servant,

Ophelia M."

"My beloved child, my poor, poor, beloved child,

My heart tells me that you are well again, and that means you will have the strength and courage, as I hope with heart and soul, to face up to what I have to say to you.

I am sure God will never forget the deed you did for my sake, and I send up a hymn of joyful praise to him for giving me the opportunity to undo it. What you must have had to go through for my sake, my dearest, my own!

That you could have told your father of my situation is not possible. I begged you to say nothing to him about it and I know you respected my desire. He would certainly have hinted at it when I went to see him, to tell him how much we loved each other and to say farewell to him – and to you.

So you are the only one who can have signed the promissory note.

Today I weep tears of joy that I can return it to you. I came across it by chance on the desk of that horrible man, whose name I refuse to speak again.

How can I express my thanks to you, my one and only child? Could there be anything I could do to prove how grateful I am? It is impossible that such great gratitude and love as I feel for you cannot reach out from the grave. I know that they will persist through all eternity, just as I know that I will be with you in spirit, accompanying your every step and protecting you from all danger, like a faithful hound, until we meet again.

We never spoke about it. How could we have had time to, when we had to embrace and kiss each other? But believe me: just as surely as providence exists, so there is a land of eternal youth. If I did not know that, where would I find the courage to leave you?

There we will meet again, never more to part; there we will both be – and stay – as young as each other, and time will be an eternal present.

There is only one thing that saddens me – but no, I am smiling at it already! That is that you will not be able to carry out my wish to bury me in the garden by our darling little bench.

I beg you, more passionately, more urgently than the last time we saw each other, to remain on earth for the sake of our love. Live your life, I implore you, until the Angel of Death should come to you of his own accord, and not because you have called him. I want you to be older than me when we meet again. That is why you must live out your full life here on earth. And I will be waiting for you over there in the land of eternal youth.

Rejoice that I am free, free at last, now, just as you are reading my letter.

Would you prefer to know that I was suffering? What that suffering would be, if I were to remain alive, cannot be put into words. I have seen – once and once only – the life that would await me, and I shudder with horror.

Better hell than such a profession!

But even that I would suffer with pleasure, if I knew it would bring me closer to the happiness of being united with you. Do not think I am throwing life away because I am incapable of suffering for your sake. I am doing it because I know our souls would be separated, both here and on the other side.

Do not think these are mere words, set down to comfort you, a delusion to ensnare you, when I say that I know that I will survive the grave and be with you once again. I *know* that it is true, I swear to you. My every nerve knows it. My heart, my blood knows it. There are a hundred portents that tell me. Waking, sleeping and in my dreams.

I can give you proof that I am not mistaken. Do you think I would be so presumptuous as to promise you something if I were not absolutely sure it would happen.

Listen; now, as you are reading these words, close your eyes.

I will kiss your tears. Do you know now that I am by you, that I am living?

Do not be afraid, my own, that the moment of death might be painful for me. I love the river so much; it will not harm me when I entrust my body to its care.

Oh, if only I could be buried beside our bench!

I will not beseech God to let it happen, but perhaps he will read my mute, childish wish and let a miracle happen. There are so many other, greater ones he has performed.

One more thing, my love. If it is possible, and when you are a true man, in the fullness of your strength, then help my poor foster-father.

But no, do not trouble yourself about it. I will be beside him myself and will support him. At the same time, it will be a sign for you that my soul can do more than my body ever could.

And now, my beloved, my faithful child, a thousand, a million kisses from your happy Ophelia."

Are these really my hands holding the letter and then slowly folding it up again?

Is this person who is touching his eyelids, his face, his chest really me?

Why are there no tears in these eyes?

Lips from the realm of death have kissed them away; even now I can still feel their caress. And yet I feel as if an infinitely long time has passed since their touch. Is it perhaps just a memory of that night in the boat, when Ophelia kissed away my tears?

Is it the dead who bring our memories back to life when they want us to feel their presence? Do they cross the stream of time to reach us by turning back the clock within us?

My soul is paralysed. How strange that my blood is still ebbing and flowing. Or is it the pulse of some other person, a stranger, that I can feel beating?

I look down at the ground. Are those my feet moving mechanically, step by step, towards the house, and now up the stairs?

They ought to be trembling, stumbling at the pain the person they belong to is suffering, if that person be me.

For a moment a terrible stabbing pain, as if I have been pierced from head to toe by a red-hot spear, knocks me sideways against the banister; then, when I search for the pain within, I cannot find it. It has burnt itself out like a bolt of lightning.

Have I died? Is my shattered body perhaps lying at the foot of the stairs? It this merely my ghost opening the door and entering the room?

No, it is no apparition; it is me. Lunch is on the table, and that is my father coming towards me and kissing me on the forehead. I try to eat, but I cannot swallow. Each bite I take swells up in my mouth. My body must be suffering, though I know nothing of it.

Ophelia is holding my heart in her hand – I can feel her cool fingers – so that it does not burst. Yes, that must be it, otherwise I would scream out loud.

I try to rejoice that she is with me, but I have forgotten how to rejoice. Rejoicing needs a body, and I have no power over it any more.

Must I then spend my days wandering over the earth, a living corpse?

Silently the old serving woman clears the table. I stand up and go to my room. My eye lights on the wall-clock: three? It should be one o'clock at the most. Why is it not ticking?

Then I realise: Ophelia died at three o'clock in the morning.

Yes, yes; now memory returns. Last night I dreamed of her! She was standing by my bed, a smile full of happiness on her face.

"I am coming to you, my love! The river has heard my plea. Do not forget your promise, do not forget your promise", she said. Her words re-echo inside me.

"Do not forget your promise, do not forget your promise", my lips keep on repeating, as if they were trying to awaken my brain so that it would finally comprehend the hidden meaning of the words. My whole body starts to become restless, as if

there were an order it was expecting me to give.

I make a great effort to think, but my mind remains dead.

"I am coming to you. The river has heard my plea!" What can it mean? What can it mean?

I am to keep my promise? What promise did I give?

I feel it like an electric shock: the promise I gave Ophelia that night in the boat! Now I know. I must go down to the river. I am in such a rush that I jump down the stairs four, five at a time, letting the banisters slide through my hands.

Suddenly I am alive again. The thoughts are racing through my mind. "It can't be true", I tell myself. "It is the most improbable story I could think up."

I try to stop and turn back, but my body drags me on. I run down the alley to the water.

There is a raft tied up to the bank with two men on it.

"How long would a tree-trunk take to float down this far from the capital?" is the question I want to ask. I walk right up to them and stand there, staring at them. They look up in astonishment. I do not manage to say anything for I can hear Ophelia's voice coming to me from the depths of my heart. "Do you not know better than anyone else when I will arrive? Have I ever kept you waiting, my child?"

Inside me all doubts are banished, and I can feel the certainty, as solid as a rock and bright as the midday sun. It is as if the whole of nature around had come to life and were calling, "At eleven o'clock tonight!"

Eleven o'clock! The hour I have always looked forward to with passionate longing!

The moon is glittering on the river, just as it was on that other night.

I am sitting on the garden seat, but I am not filled with my usual expectation; I am united with the stream of time, how then should I want it to go faster or more slowly?

It is written in the Book of Miracles that Ophelia's last wish is to be fulfilled! The thought is so shattering that everything

else – Ophelia's death, her letter, the gruesome task of burying her corpse, the cruel emptiness of the life that awaits me – pales in comparison.

I am suddenly seized with the notion that the myriad stars above are the all-knowing eyes of the archangels, looking down and watching over us. I feel a boundless power close round me, flowing through me. In its hand all things become living tools; a puff of wind touches my face, and I feel it saying to me, "Go to the river bank and untie the boat."

No longer are my actions guided by thought. I am woven into nature, its secret whispering is my comprehension.

Calmly I row out into the middle of the river.

Now she will come!

A patch of light is floating towards me. A white face, the features rigid, the eyes closed, is drifting on the smooth surface like an image in a mirror.

Then I am holding the dead Ophelia in my arms and pulling her into the boat with me.

I have bedded her deep in the soft, pure sand by our beloved seat on a cushion of scented elderflowers and covered her with green boughs.

The spade I cast into the river.

Chapter 9

Solitude

I had imagined the news of Ophelia's death would become known the very next day and spread like wildfire through the town, but week after week passed, and nothing was heard. Eventually I realised that Ophelia had taken her leave of this earth without telling anyone but myself.

I was the only living being on earth who knew of it.

I was filled with a strange mixture of indescribable loneliness and an inner richness that needed no one to share it. All the people around me, even my father, seemed like figures cut out of paper, as if they were not part of my life but just background scenery.

I would spend hours every day sitting on the garden seat dreaming, with an almost constant sense of the closeness of Ophelia; and whenever I thought to myself, 'Here, at my feet, her body, that I loved so passionately, is sleeping', I would be filled with such astonishment that I was incapable of feeling sorrow.

How sensitive, how right had been her instinct when she had asked me, during that night in the boat, to bury her here and to tell no one! Now the two of us – she on the other side and I here – were the only ones who knew, and this knowledge held us in such intimate communion that at times I did not even feel her death as an absence of her body.

I only needed to imagine her lying in the town cemetery under a gravestone, surrounded by the dead and mourned by her relatives, for the thought to pierce my breast like a knife, banishing the sense of her spiritual proximity to a place beyond reach.

The vague belief people have that death is not an unbridgeable chasm, but merely a thin partition separating visibility and invisibility, would turn into absolute certainty if they would

bury their dear departed ones in places only they knew of, only open to them, instead of in public graveyards.

Whenever my sense of solitude became especially intense, I would remember that night when I had laid Ophelia's body to rest as if it had been myself I had buried, as if I were a mere ghost on earth, a wandering corpse which no longer had anything in common with people of flesh and blood.

There were moments when I had to tell myself, 'This is not you any more. A being, whose origin and existence lie hundreds of years before yours, is slowly, inexorably penetrating your shell and taking possession of it until soon there will be nothing left of you, apart from a memory floating in the realm of the past, on which you can look back as on the experiences of someone who is a complete stranger to you.'

It was our Founding Father, I realised, risen again within me.

Whenever my gaze was lost in the haziness of the misty heavens, images of unknown regions and alien landscapes would appear before my eyes. I heard words which I grasped with some inner organ without, oddly enough, being able to comprehend them; I understood them in the same way as the earth receives and stores seeds, to bring them to fruition much later; I understood them as things which you feel that one day you will truly understand.

They came from the lips of people in foreign dress who seemed like old acquaintances, even though I could not possibly have ever seen them in this life. The words were addressed to me, and yet their origins lay a long way back; they were suddenly born from the past into the present.

I saw snowy peaks rising to the sky, their ice-bound summits higher than any clouds. 'That is the roof of the world', I told myself, 'the mysterious land of Tibet.'

Then there were endless steppes with caravans of camels, Asian monasteries in deepest solitude, priests in yellow robes carrying prayer-wheels in their hands, rocks that had been carved into huge statues of the seated Buddha, rivers which seemed to come from infinity and flow into infinity; the banks

were a landscape of loamy hills, the tops of which were all flat, flat as tables, flat as if they had been mown with a gigantic scythe.

I guessed that these must be regions, objects and people that our Founding Father had seen when he was still wandering the earth. Now that he was entering me, his memories would also be mine.

On Sundays, when I came across young people and saw how in love they were, how they were enjoying life, I could certainly understand what they were feeling, but inside me was nothing but cold. It was not the freezing cold which comes from a pain which chills emotion to its very core; nor was it the cold that comes from the weakening of the life-force in old age.

The sense of immense age was so powerful, so permanent within me as never before, and often, when I saw myself in the mirror, I was surprised to see a youthful face looking at me, with no sign of frailty in it; the deadness had taken hold solely of the bond that ties men to the pleasures of this earth, the cold came from regions alien to me, from a glacial world that is the home of my soul.

At that time I could not fathom the state that had taken hold of me. I did not realise that one of those mysterious, magical transformations was in progress that we often find depicted in the lives of Catholic and other saints without comprehending their depth or their significant vitality. As I felt no yearning for God, I had no explanation for it, nor did I seek one. I was spared the scorching thirst of an unquenchable yearning, of which the saints speak and in which, they say, all earthly concerns are consumed by fire, for the only possible object of my yearning was Ophelia, and I bore within me the assurance of her constant nearness.

Most events in the physical world passed me by without leaving any trace in my memory. The images from that time are like a dead lunar landscape full of extinct volcanoes without a path or track to connect them to each other. I cannot remember the things my father and I said to one another, weeks have

110

shrunk to minutes, minutes expanded to years. Now that I am using the hand of another to review the past I feel as if I must have spent years sitting on the garden seat by Ophelia's grave. For me, the chain of experience, by which we measure the flow of time, consists of disconnected links hanging in the air.

I know that one day the water-wheel that turned the carpenter's lathe stood still and the whirring of the machine stopped, filling the alleyway with a deathly hush; but when it happened, whether on the morning after that night or later, has been expunged from my memory.

I know I told my father that I had forged his signature; it cannot have happened in a rush of emotion, for I cannot remember any such outburst. Nor can I remember the reasons I had for doing it. All I have is a faint recollection of feeling a certain pleasure in the fact that there were no longer any secrets between us. And in connection with the mill-wheel standing still, all that comes back to me is the feeling of happiness that old Mutschelknaus did not have to work any more.

And yet I am sure it could not have been I who felt these emotions, they must have been transmitted to me from Ophelia's spirit, so dead to all human concerns was the Christopher Dovecote whose image I now see before me.

That was the time when the name that had attached itself to me, 'Dovecote', became like a prophecy from the lips of fate that had been fulfilled: I was a lifeless dovecote, the place where Ophelia resided, and the Founding Father, and the primal essence that goes by the name of Christopher.

There is much knowledge I possess which has never been recorded in books. No one ever revealed it to me and yet it is there. I assume it awoke within me during that time in which my outer form, in a sleep that resembled death, was transformed from a shell surrounding ignorance to a vessel of knowledge.

At that time I believed, just as my father believed up to the day of his death, that the soul could become richer in experience and that the life of the body could be used to that end. That was the way I had understood our Founding Father's warning.

Now I know that the soul of man is all-knowing and all-powerful from the very beginning, and that the only thing man can do – if there is anything at all that lies within his power! – is to remove all the obstacles that hinder its development.

The most profound secret of all secrets, the most hidden mystery of all mysteries, is the alchemical transformation of external form. – This I say to you who have put your hand at my disposal, as a token of my thanks for writing this down for me. –

The hidden path leading to rebirth in the spirit, which is talked about in the Bible, is a transformation of the body and not of the spirit. The spirit expresses itself through physical form; it is constantly carving and moulding it; the more rigid and incomplete the form, the more rigid and incomplete the manner of its revelation; the more responsive and subtle the form, the more manifold its manifestation.

It is God alone, the all-pervading spirit, who transforms it and spiritualises our bodies so that our innermost, primal being does not send its prayer outside, but worships its own form, limb by limb, as if each part were a different image of the divinity residing concealed within.

The change in physical form that I am talking about only becomes visible to the eye when the alchemical process of transformation is approaching completion. Its origins lie hidden in the magnetic currents which determine the axis of our physique. It is our way of thinking, our inclinations and instincts which are transformed first of all, followed by a change in behaviour and, with that, the metamorphosis of physical form until it becomes the body of the resurrection from the Gospel.

It is as if a statue of ice were to begin to melt from within.

The time is coming when the doctrine of this alchemy will be erected once more for many; it lay as if dead, a pile of rubble, a ruin which is the ossified system of India's fakirs.

Under the transforming influence of our spiritual forefather I had become, as I said, an automaton whose senses were cold, and that I remained until the day of my 'Dissolution with the

Corpse'. If you want to understand what I was like during that time, you must see me as a lifeless dovecote, with the birds flying in and out without my being in any way involved in their activity. You must not measure me by the yardstick of human beings, who know their own kind alone.

Chapter 10

The Garden Seat

There is a rumour going round the town that Mutschelknaus has gone mad.

Frau Aglaia has a doleful expression. Early in the mornings she sets off with her little basket for the market to do the shopping herself, for she has dismissed her servant. Day by day her dress is getting dirtier and slovenlier, the heels of her shoes are worn down. Sometimes she stops in the middle of the street and mutters to herself, like someone who is so worried they do not know where to turn.

Whenever I meet her, she looks the other way. Or is it that she does not recognise me any more? Anyone who asks after her daughter is informed curtly that she is in America.

Summer has ended and autumn and winter have passed, and I have not seen the carpenter once. I have no longer any idea whether years have passed since then, whether time is standing still or whether one single winter seemed so interminably long to me. But I can feel now that it must be spring again, for the air is heavy with the scent of blossom, after the storms the paths are strewn with blooms, the young girls are wearing white dresses and have flowers in their hair.

The air is vibrant with music.

The rambling roses are hanging down the embankment walls and trailing in the river, which carries their delicate, foamy pink sprays past each square block to the pillars of the bridge, where they adorn the rotting beams so that they look as if new life were sprouting from them.

In the garden, the grass in front of the seat has an emerald glow.

Often, when I go down there, I can tell from all kinds of tiny changes that someone must have been there before me. Sometimes there are little pebbles on the bench, set out in the form of

a cross or a circle, as if a child had been playing with them; at others, there are flowers strewn all around.

One day, as I was going down the alley, the old carpenter came towards me from the garden, and I guessed that he must be the one who sat on the seat when I was not there. I greeted him, but he seemed not to notice me, although our arms touched.

He was staring straight ahead, absentmindedly, a happy smile on his face.

Soon after that we chanced to meet in the garden. Without a word, he sat down beside me and started to trace the name of Ophelia with his stick in the strip of white sand. We sat like that for a long time, and I was somewhat bewildered. Then all at once he began to mutter softly; at first it sounded as if he were talking to himself or to some invisible person, only gradually did his words become audible to me. "I am glad that only you and I come here. It's good that no one knows about this seat, Christopher."

I started in astonishment. He was calling me by my first name?!

Was he confusing me with someone else? Or was his mind wandering? Had he forgotten the submissive formality with which he used to address me?

What did he mean by "It is good that no one knows about this seat"?

The sense of Ophelia's presence was suddenly so close that I felt as if she were standing in front of us. The old man felt it too; he quickly raised his head and his features were illuminated with a radiant joy.

"You know, she's always here. When I go home, she accompanies me a short way and then comes back here", he murmured. "She told me she waits here for you. She loves you, she said!" In a friendly gesture, he put his hand on my arm, looked long and happily into my eyes and added softly, "I'm glad she loves you."

At first I did not know what to say to that. Eventually I man-

aged to stammer, "But – but your daughter – your daughter's in America, isn't she?"

The old man placed his lips close to my ear and whispered mysteriously, "Sh! No. That's just what people – and my wife – believe. She died. But we are the only ones who know that, you and me. She told me you know as well. Not even Herr Paris knows." He saw my astonished look, nodded and repeated his assertion, "Yes, she died. But she's not dead. The Son of God, the White Dominican, took pity on us, and allowed her to stay with us."

I realise that the old man is in the grip of the strange psychical state that savage tribes call sacred madness. He has become a child, plays with stones like a child, speaks clearly and simply like a child, but his mind is clairvoyant.

"How was it that you learnt all this?" I ask.

"I was working at the lathe during the night", he began, "when the water-wheel suddenly stopped and I could not get it started again. Then I fell asleep at the table. I saw my Ophelia in a dream. She said, 'Father, I don't want you to go on working. I am dead. The stream is refusing to turn the water-wheel, and I will have to do it if you refuse to stop working. Do stop, I beg you. Otherwise I will have to stay outside by the river and I won't be able to come in to be with you.' When I woke up I ran straight to St. Mary's, even though it was still night. It was pitch black and deathly still. But inside, the organ was playing. I thought, 'But the church is locked, you can't get in.' But then I thought, 'Of course I can't get in if I doubt it', and stopped doubting. Inside it was quite dark, but the White Dominican's cassock was so snowy white I could see everything from my seat below the statue of the Prophet Jonah. Ophelia was sitting next to me and explained everything that the Saint, the great one of the White Order, was doing.

First of all he went to the altar and stood there with his arms outstretched like a huge cross, and the statues of all the saints and prophets did the same, one after the other, until the church was full of living crosses. Then he went to the glass reliquary

and put something in it that looked like a small black pebble.

'It's your poor brain, father', my daughter Ophelia said. 'Now he has locked it away in his treasury, for he does not want you to torment it for my sake any more. When the time comes for it to be returned to you, it will be a precious stone.' The next morning I felt I had to come out to this seat, but I didn't know why. Here I see Ophelia every day. She always tells me how happy she is and how beautiful it is over there in the Land of the Blessed. My father, the coffin-maker, is there as well, and he has forgiven me everything. He's not even angry with me any more for letting the glue burn when I was a lad.

When evening comes in paradise, she says, then the theatre opens, she says, and the angels come to watch her act Ophelia in the play The King of Denmark, and at the end she marries the Crown Prince and they are all pleased at how good she is at it, she tells me. 'And I have you to thank for that, dear father, you alone', she keeps on saying, 'for you made it possible for me to learn to act the part when I was on earth. To be an actress was always my deepest desire, and you allowed me to fulfil it, father.' "

The old man is silent and gazes ecstatically up at the heavens.

I have a horribly bitter taste on my tongue. Can the dead lie? Or is he just imagining it all? Why does Ophelia not tell him the truth, gently, if she can communicate with him? The dreadful thought that the kingdom of lies stretches to the other side begins to gnaw at my heart.

Then realisation strikes. I am gripped so powerfully by Ophelia's presence that I suddenly grasp the truth. It is not Ophelia herself that he sees and hears, only her image. It is a phantasm, born of his long-felt desires; his heart has not become cold like mine, and therefore it sees the truth distorted.

"The dead can perform miracles, if God wills it", the old man goes on. "They can take on flesh and blood and walk among us. Do you believe that?" He asks the question in such a firm voice that it almost sounds like a threat.

My answer is equivocal, "I consider nothing impossible."

The old man seems satisfied and is silent. Then he stands up and goes. Without saying goodbye. The next moment he comes back, stands in front of me and says, "No, you don't believe it. Ophelia wants you to see for yourself and believe. Come."

He takes my hand as if he were going to drag me along with him. Hesitates. Listens as if there were a voice in the air. "No, not now. Tonight", he mutters absentmindedly to himself. "Wait for me here tonight."

He goes. I watch him feel his way along the house wall, tottering like a drunken man.

I have no idea what to think.

Chapter 11

The Head of the Medusa

We are sitting around a table in a tiny, unutterably poverty-stricken room: Mutschelknaus the carpenter, a little, hunch-backed seamstress that people in the town say is a witch, a fat old woman and a man with long hair, neither of whom I have seen before, and myself.

On the dresser a nightlight is burning in a red glass; above it is a cheap, brightly coloured print of the Mother of God, her heart pierced by seven swords.

"Let us pray", says the man with the long hair, beating his breast and reciting the Lord's Prayer mechanically. His hands are gaunt and as white as the hands of poor, anaemic school-teachers. He has sandals on his bare feet.

The fat woman sighs and sobs, as if she were about to burst into tears at any moment.

"For thine is the kingdom, the power and the glory, for ever, amen, let us form the chain and sing, for the spirits love music", says the man with the long hair in one breath. We hold each other by the hands on the table top and the woman softly starts to sing a hymn. They both sing flat, but there is such true humility and fervour in their voices that, in spite of everything, I am moved.

Mutschelknaus is sitting motionless; his eyes are bright with blissful anticipation.

The hymn finishes.

The seamstress has fallen asleep. I can hear the rasp of her breath. She has laid her head between her arms on the table. There is a clock ticking on the wall, everything else is deathly silent.

"There is not enough power here", says the man, giving me a reproachful look from the side, as if I were to blame.

There is a creaking noise in the dresser, as if wood were splitting.

"She is coming!" whispers the old carpenter excitedly.

"No, it is Pythagoras", the old man with the long hair informs us.

The fat woman sobs.

This time the creaking and cracking comes from the table; the hands of the seamstress begin to jerk rhythmically, as if in time to the beat of her pulse. For a moment she raises her head – the iris has disappeared under the upper lid, you can only see the white – then she lets it sink down again.

I once saw a little dog die; it was just like that. I feel the seamstress has slipped over the threshold of death.

The rhythmical twitching of her hands is transferred to the table; it is as if her life force had entered it. Under my fingers I can feel a soft tapping in the wood, as if bubbles were rising and bursting. They give off an icy cold as they burst which spreads out, hovering over the table-top.

"It is Pythagoras!" says the man with long hair in a tone of deep conviction.

The cold layer of air over the table comes alive and begins to circle; it makes me think of the 'deadly north wind' that my father talked of during his midnight conversation with the Chaplain.

Suddenly the silence is shattered by a loud crash: the chair the seamstress was sitting on has been torn from under her; she is lying stretched out on the ground.

The woman and the man lift her onto a bench by the stove. When I ask them whether she has hurt herself, they shake their heads and sit down at the table once more. From where I am sitting, I can only see the seamstress' body, her head is hidden by the shadow of the dresser.

In the street outside a lorry passes, making the walls tremble; the sound of the wheels has long since disappeared, but strangely the walls continue to quiver.

Or am I deceiving myself? Is it perhaps simply that my senses have grown sharper and can perceive something they would otherwise have missed, the soft after-vibration of objects that

120

goes on for much longer than is generally thought?

At times I am forced to close my eyes because the red glow of the nightlight irritates them; wherever it falls, the shapes swell and the outlines merge. The body of the seamstress is like a soft lump of dough; she has fallen from the bench onto the floor.

I have resolved not to look up until something decisive happens. I want to remain master of my senses. I feel an inner warning – 'Be on your guard!' – and deep suspicion, as if something fiendish and evil were there in the room, some awful being formed from congealed poison.

The words from Ophelia's letter come back to me, so clearly that I can almost hear them. "I will be with you in spirit, protecting you from all danger."

Suddenly all three of them cry out, as with one voice, "Ophelia!"

I look up to see, hovering over the body of the seamstress, a blueish cone of spiralling mist with the point upwards; another, similar one is descending, point downwards, from the ceiling, seeking the first, until they meet and join to form a hour-glass the height of a man.

Then, suddenly, like the image from a magic lantern when someone twists it into sharp focus, the outlines are clear, and there is Ophelia in person, in the flesh. So clear, so tangible is she, that I exclaim out loud and am about to rise and rush towards her. At the last moment I am pulled back sharply by a cry of fear within my own breast, a double cry from two voices, "Hold fast to your heart, Christopher!"

"Hold fast to your heart", comes a shrill cry from within me, as if our Founding Father and Ophelia were calling out at the same time.

The phantom comes towards me, an ecstatic look on its face. Every fold of the dress is just as it was when she was alive. The same expression, the same beautiful, dreamy eyes with their long black lashes, the delicate line of the brows, the slim, white hands, even the lips are red with a living freshness. Only her

hair is concealed by a veil. Tenderly, she bends down towards me, I can hear her heart beating; she kisses me on the forehead and wreathes her arms round my neck. I can feel the warmth of her body against my skin. "She has awoken to life again", I tell myself, "there can be no doubt about it."

The blood begins to race in my veins, my suspicions begin to give way to a sweet joy, but Ophelia's voice continues to cry out in ever more fearful tones; it is like someone wringing their hands in impotent desperation. Finally I seem to be able to understand the words, "Do not leave me! Help me! He is only wearing my mask!" But then the voice is muffled, as if it came from under sheets.

"Do not leave me!" That was a cry for help! It pierces me to my innermost core. 'No, my Ophelia, you live inside me and I will not abandon you.'

I clench my teeth and turn cold, cold with suspicion.

'Who is this 'he' who is supposed to be wearing Ophelia's mask?' I ask myself as I scrutinise the phantom's face. For a split second the face of the spectre freezes in an expression of stony lifelessness, the pupils contract as if they had been struck by a ray of light. It was like the lightning disappearance of some being that was afraid of being recognised, but in spite of the speed with which it happened, for a heartbeat I saw the tiny image of another's head instead of my own in the eyes of the phantom.

The next moment the ghost has left me and is floating with outstretched arms towards the old carpenter, who embraces it and covers its cheeks with kisses, sobbing out loud with love and joy.

I am seized with an indescribable feeling of horror. I feel my hair stand on end; the air is like an icy breath, freezing my lungs.

Hovering in front of me I can see the image of that other head, tiny as the point of a needle and yet clearer and sharper than anything the eye can see. I close my lids and shut it in my mind. The face darts to and fro, like a patch of light in a mirror, then I force it to stand still and we stare at each other.

It is the face of a being of a strange, inconceivable beauty, the face of a girl and at the same time that of a boy. The eyes have no iris, they are as empty as the eyes of a marble statue and glitter like opals.

Around the thin, bloodless lips, drawn up at the corners by fine lines, is the suggestion of an expression of all-destroying mercilessness, only a suggestion, but all the more terrible for that. Its white teeth shine through the silken skin in a gruesome, bony smile.

I sense that this face is the optical point between two worlds; it is like a burning-glass in which are gathered the rays of an empire of hate and destruction behind which lurks the chasm of universal disintegration, of which the Angel of Death is but the mildest symbol.

'What is that figure that appears to be Ophelia?' is the fearful question I ask myself. 'Where did it come from? What power in the universe brought her likeness to life? It can walk, its movements are full of goodness and grace, and yet it masks a satanic power. Will the demon behind it suddenly throw off its disguise and grin at us in all its fiendish hideousness, simply in order thrust a few poor mortals into despair and disappointment?'

'No', I suddenly realise. 'The Devil would not reveal himself for such a trifling purpose.' Whether it was the primal essence within me that whispered it, whether it was the living voice of Ophelia in my heart which spoke, or whether it was the wordless source of understanding in my own being I can no longer say, but I suddenly knew that it was the impersonal force of all evil, using the mute laws of nature to conjure up miracles which in reality are only hellish phantasms serving the ends of the spirit of negation. The thing wearing the mask of Ophelia has no spatial substance; it is her magic image in the old carpenter's memory which, under metaphysical conditions that we do not understand, has made itself visible and tangible, perhaps with the fiendish intent of widening even more the gap that separates the realm of the dead from that of the living. It is the soul of the

poor hysteric seamstress – a soul which has not yet reached a pure crystallised form of personality – that has provided the matter, emerging from the medium's body like magnetic modelling clay, from which Mutschelknaus created that spectre. This is the head of the Medusa, that symbol of the petrifying force that sucks us down, at work here on a small scale, bringing blessings to the poor, like Christ, stealing into their dwellings like a thief in the night.

I look up: the spectre has vanished, the seamstress is wheezing, my hands are still on the table. Mutschelknaus leans over to me and whispers, "Don't say that it was my daughter Ophelia, no one is to know that she is dead; all they know is that it was the apparition of a being from Paradise that loves me."

Then, like a commentary on my thoughts, the voice of the man with long hair begins to declaim. He addresses me in the strict tones of a schoolmaster,

"Go down on your knees and thank Pythagoras, young man! At Herr Mutschelknaus' request I asked him, through the medium, to allow you to take part in our séance so that you might be cured of your doubts. – The spiritual star, Fixtus, has detached itself from the cosmos and is speeding towards our earth. – The resurrection of all the dead is at hand. – The first harbingers are on their way already. The spirits of the departed will walk amongst us like living men, and the ravenous beasts will once more eat grass, as they did in the Garden of Eden. – Is it not so? Is that not what Pythagoras said?"

The fat woman gives a gurgle of affirmation.

"Young man, renounce the vanity of the world! I have made my way on foot (he pointed to his sandals) across the whole of Europe and I say to you, there is not one street today, not even in the smallest village, where there are no spiritualists. Soon the movement will flood the whole world like a spring tide. The power of the Catholic Church is broken, for the Saviour will come in His own form."

Mutschelknaus and the old woman are nodding ecstatically, the words to them are glad tidings promising the fulfilment of

124

their longing; but to me they are the prophecy of a terrible time to come.

Just as, before, I saw the head of the Medusa in the eyes of the phantom, so now I can hear its voice from the lips of the man with long hair, both of them disguised behind the mask of sublimity. It is the forked tongue of a viper from the realm of darkness that is speaking. It talks of the Saviour and means the Devil. It says, 'The ravenous beasts will once more eat grass.' By the grass it means the innocent, the unsuspecting, the great mass of people, and by the ravenous beasts it means the demons of despair.

The dreadful thing about the prophecy is – and I can feel it– that it will come to pass. But the most dreadful is that it is a mixture of truth and fiendish cunning. The empty masks of the dead will arise, but not the ones we long for, not the departed for whom those left on earth shed their tears! They will come dancing to the living, but it will not be the dawn of the millennium, it will be a carnival of Hell, a fiendish rejoicing in expectation of the cock-crow of a never-ending, gruesome, cosmic Ash Wednesday!

"Should the day of despair dawn today for the old man and the others? Is that what you wish?" I can hear it resounding, like a mute, mocking question, in the voice of the Medusa. "If that is so, I will not stop you, Christopher. Say the word. Tell them, you who believe you have escaped my power, tell them that you have seen me in the pupils of the phantom that I created and made to walk out of the cancerous cells of the decaying robe that clothes the soul of the seamstress! Tell them everything you know. I will back you up, and they will believe you.

I will be happy for you to carry out the work that is the task of my servants. Be a harbinger of the great White Dominican who is to bring the truth, as your ancestor hopes. Be a servant of the glorious truth, I will willingly bring about your crucifixion. Be bold, tell those gathered here the truth. I look forward to seeing how 'redeemed' they will feel."

The three spiritualists are looking at me, full of expectation

of my reply to the man with long hair. I remember the place in Ophelia's letter, where she asked me to assist and support her foster-father and I hesitate. Should I tell them what I know? One glance at the joy in the shining eyes of the old man robs me of all my courage. I remain silent.

I feel that it is only in the hearts of those who have come alive in the spirit that the dead can find true peace; there alone is rest and refuge for them. If the hearts of men are sleeping, then the dead will sleep in them too; if their hearts wake to spiritual life, then the dead will also come alive and partake of the world of appearances, without being subject to the torment that accompanies earthly existence.

I am overcome with a sense of impotence, of complete powerlessness, as I wonder what I can do, now that it is in my power to speak or to remain silent. And what shall I do later, when I am mature, perhaps one of the perfected, one who has achieved spiritual completion? The time is at hand when belief in mediums is about to inundate the world, like a pestilential flood-tide, of that I feel certain. I picture the abyss of despair which will engulf mankind when, after a short frenzy of delight, they see that the dead that are rising from their graves lie, lie, lie worse than any creature on earth ever could lie, they are demonic phantoms, embryos sprung from an infernal act of copulation.

In that day, what prophet will be strong enough to halt such a spiritual end of the world?

All at once my silent reflections are interrupted by a strange sensation: I feel as if my two hands, which are still lying idle on the table before me, have been grasped by beings that I cannot see. I sense that a new magnetic chain has been forged, similar to the one at the beginning of the séance, only in this one I am the only living link.

The seamstress gets up from the floor and comes to the table. Her expression is calm, as if she were fully conscious.

"It is Py ... Pytha ... Pythagoras", says the man with the long

hair, but the hesitant, wavering tone of his voice is full of doubt. He seems puzzled by the normal, sober look on the face of the medium.

The seamstress looks me in the eye and says, in a deep voice like a man's, "You know that I am not Pythagoras."

A quick glance at the others tells me that they cannot hear what she is saying, their faces are devoid of expression. The seamstress nods in confirmation. "I am talking to you alone, the ears of the rest are deaf. The linking of hands is a magic process; if hands are joined that have not yet come alive spiritually, then the realm of the Medusa rises from the abyss of the past and the depths spew forth the masks of the dead; but the chain of living hands is the rampart protecting the refuge of the upper light. The servants of the head of the Medusa are our instruments, but they do not know it; they believe they are destroying, but in fact they are creating space for the future; like worms devouring dead flesh, they gnaw at the corpse of materialism and devour it; if they did not, its putrefying stench would corrupt the earth. They hope that their day is dawning, the day when they can send the ghosts of the dead out among the living. We are quite happy to let them be. They want to create a void, one that goes by the name of madness and absolute desperation and that will swallow up all life, but they do not know the law of 'fulfilment'. They do not know that the fountain of help only starts to flow from the realm of the spirit when the need is there.

And it is they who are creating this need!

They are doing more than we do. They are calling down the new prophet. They are overthrowing the old church and do not realise that they are calling up the new one. They want to devour living things, but all they devour is what is decaying. They want to eradicate humanity's hope for a life after death and only eradicate what must anyway fall. The old church has become black and lightless, but the shadow it casts on the future is white. The forgotten doctrine of the 'Dissolution with Corpse and Sword' will be the basis of the new religion and the armoury of the spiritual pope.

127

Do not worry about him" – the seamstress turned her gaze towards the carpenter, who was staring blankly ahead – "or his kind; no one who is honest is heading for the abyss."

The rest of the night until the sun came up I spent on the seat in the garden, happy in the knowledge that it was only the form of my lover that was sleeping there at my feet. She herself is as awake as my heart, is inextricably bound up with me.

The dawn rose from the horizon, night clouds hung down to the ground like heavy, black curtains; orange and violet patches formed a gigantic face whose rigid features reminded me of the head of the Medusa. It hovered there motionless, as if it were lying in wait to devour the sun. The whole looked like a shroud from hell with the face of Satan imprinted on it.

Before the sun came, as if in greeting, I broke a branch off the elder tree and, so that it would flourish and grow into a tree itself, planted it in the ground. I felt as if, in doing that, I was enriching the world of life.

Before the great light appeared, the first harbingers of its radiance had erased the head of the Medusa. The clouds that had been so dark and menacing were transformed into an innumerable flock of white lambs drifting across the glorious sky.

Chapter 12

He Must Increase, but I Must Decrease

I woke one morning with these words of John the Baptist on my lips. From the day I spoke them to my thirty-second year they were like a motto governing my life.

"He's getting to be an eccentric like his grandfather", I heard the old folk mutter when I met them in the town. "He's going downhill month by month."

"He's an idle layabout who wastes every hour God gave us", said my hard-working neighbours. "Has anyone ever seen him work?"

In later years, when I was a man, the gossip had hardened into the certainty that I had the evil eye – "Keep out of his way, his look brings misfortune!" – and the old women in the market-square would hold out the 'fork' – index and middle fingers outspread to ward off the 'magic' – towards me, or they would cross themselves.

Others maintained I was a vampire, one of the undead that came back in the night to suck the blood from the children as they slept; if two red spots were found on the neck of an infant, then people would say they were the marks of my teeth. Many claimed to have seen me, half wolf, half man, in their sleep and would run away screaming whenever they caught sight of me in the street. The place where I used to sit in the garden was considered bewitched, and no one dared to pass through the alleyway.

There was a series of strange happenings, which gave the rumours some semblance of truth.

Once, late in the evening, a large shaggy dog with the look of a beast of prey and which no one had ever seen before ran out of the house of the hunchbacked seamstress and the children in the street cried out, "The werewolf! The werewolf!" A man hit it on the head with an axe and killed it.

At about the same time a tile fell off the roof, wounding me in the head; when I appeared the next day with a bandage round my head, people said I had been the nightmare beast and that the werewolf's wound had transferred itself to me.

Another time, in the middle of the day in the market square, it happened that a man from outside the town, a tramp who was generally considered to be weak in the head, threw up his arms in apparent horror as I came round the corner, and fell to the ground, dead, his features contorted as if he had seen the Devil.

Then again the police were dragging a man through the streets who was resisting with all his might, moaning all the time, "How can I have murdered someone, I've spent the whole day asleep in the barn?" I happened to come along, and when the man caught sight of me, he threw himself to the ground and pointed at me, crying, "That's him! Let me go, he's come back to life!"

Each time this kind of thing happened a thought appeared in my mind, saying, 'They have all seen the head of the Medusa in you. It lives inside you, and those that see it all die, while those who just sense it are filled with horror. That night you saw mortality in the pupils of the spectre, the seed of death that resides in you, as it does in all men. Death resides in men, that is why they do not see it; they do not carry 'Christ', they carry death within them, it consumes them from inside like a worm. Only someone who has disturbed it, as you have, can see it face to face; such people it will 'face up to'.'

And truly, at that time the earth became, from year to year, an ever darker valley of death for me. Everywhere I looked, in every shape and word and sound and gesture, I was surrounded by the constantly shifting influence of the terrible lady that rules in the world, the Medusa with the beautiful, and yet so grue-some face.

'Earthly life is the continuing torture of giving birth to death, to a death that is renewed every second', that was the insight that stayed with me night and day. 'The only purpose of life is

the revelation of death.' Thus all thoughts within me had been transposed into the opposite of normal human feeling. 'The desire to live' seemed like theft from the being that shared my earthly form, and the 'inability to die' like the hypnotic command of the Medusa, "I want you to remain a thief, a robber and a murderer, and to walk the earth as such."

The verse from the Gospel, "He that loveth his life shall lose it; and he that hateth his life in this world shall keep it unto life eternal", began to rise from the darkness for me, shining brightly. I understood its meaning: the one that must increase is our Founding Father, but I must decrease!

When the tramp fell down dead in the market-place and his features began to go rigid, I was standing among the people crowding round him and I had the uncanny feeling that his life-force was seeping into me, like refreshing air after a shower of rain. I slunk away, laden with a sense of guilt, as if I really were a bloodsucking vampire, aware of the ugly fact that my body only survived by stealing life from others; it was a walking corpse that was cheating the grave of its due. It was only the strange coldness of my heart and my senses that stopped me from rotting alive like Lazarus.

The years passed. I can almost say that the only thing by which I noticed their passing was the way my father's hair became whiter and whiter and his figure more bent and aged.

So as not to encourage the townsfolk in their superstition, I went out less and less until finally I stayed at home for years and did not even go down to the garden seat. In my mind, I had carried it up to my room and sat on it for hours, letting Ophelia's presence flow through me. Those were the only hours when the kingdom of death had no power over me.

My father had fallen into a strange silence; often weeks would pass without us exchanging a word apart from a 'Good morning' and a 'Good night'. We had almost abandoned speech but, as if thought had carved out new channels of communication, each of us could always tell when the other wanted something. Now I would hand him some object, now he would

take down a book, leaf through it and give it to me; almost every time I found it opened at the place that had been going through my mind.

I could tell by the way he looked that he was perfectly happy. Sometimes his eye would rest on me for a long time with an expression of absolute content.

Sometimes we were both aware that for a whole hour we had followed the precisely same train of thought; we were, so to speak, marching intellectually side by side, keeping step with each other, so that eventually the silent thoughts did turn into words. But it was not like in the past, when the words came too soon or too late, but never at the right time. Rather, we were continuing a thought process, not feeling our way or looking for an opening.

Such moments are so vivid in my memory that the whole surroundings come alive in the smallest detail whenever I think back to them. I can hear my father's voice again in every word, in every note, as I write down what he said one day when I had been reflecting on what the purpose of my strange deadness might be.

"We all have to turn cold, my son, but with most people life is not capable of bringing it about and death has to do it. Dying does not mean the same for everyone. With some, so much dies at the hour of death that one can almost say that there is nothing left. All that remains of some people is their works here on earth; their fame and their services live on for a while and, strangely enough, in a certain sense their bodies live on, for they have statues built in their honour. How little good and evil are involved can be seen by the fact that even the great destroyers such as Nero or Napoleon have their monuments. It is all a matter of how outstanding their deeds were.

The spiritualists maintain that suicides, or people who have come to some grisly end, are bound to the earth for a certain period. I rather tend to the opinion that it is not their spectres that manifest themselves at séances or in haunted houses, but their images together with certain factors connected with their

132

deaths. It is as if the magnetic atmosphere of the place preserves the event and releases it from time to time. Many features of the conjuration of the spirits of the departed in Ancient Greece – that performed by Tiresias, for example – suggest that this is the case.

The hour of death is merely that point in a catastrophe at which everything in a person that could not be worn down during life is blown away, as if in a storm. You could also put it this way: first of all the worm of destruction eats away the less important organs – that is what we call growing old – but once it reaches the pillar of life, then the whole building collapses. That is the normal course of things.

Such will be my end, for my body contains too many elements which it is beyond my power to transmute by alchemy. If you were not here, my son, then I would have to return to continue the interrupted work in a new incarnation. It says in the books of wisdom of the East, "Have you fathered a son, planted a tree and written a book? Only then can you begin the great task."

In order to avoid having to return, the priests and kings in ancient Egypt had their corpses embalmed. They wanted to avoid the legacy of their cells being passed back to them and forcing them to return to new work on earth.

Earthly talents, weaknesses and defects, knowledge and intellectual gifts belong to the bodily form and not to the soul. I for my part, as the last branch on the family tree, have inherited the body cells of my ancestors; they went from one generation to the next, and finally to me. I can sense you wondering, 'How can that be? How can the body cells of my grandfather be passed on to my father if he did not die before the birth of his off-spring?'

The cells are passed on in a different way. It does not take place at conception or birth, nor in a crude, physical manner, as if you were pouring water from one vessel into another. It is the particular fashion in which the cells crystallise around a central point that is inherited, and even this does not happen all at once,

but gradually. Have you never noticed – it is a comical fact that gives rise to much amusement – how old bachelors who have a pet dog transmit their likeness to the animal over the years? What happens there is an astral transfer of 'cells' from one body to another; you impress the stamp of your own being on anything you love. The reason why pets have such social awareness is simply because human cells have been transferred to them. The more deeply human beings love each other, the more 'cells' they exchange, the more they fuse with one another, until one day, after billions of years the ideal state will have been reached in which humanity consists of one single being made up of countless individuals. On the day your grandfather died I, as his only son, came into the last inheritance of our line.

I found it impossible to mourn for him, even for an hour, so quickly did his whole being enter me. The layman may find it a gruesome thought, but I could literally feel his body decomposing day by day in the grave, without finding it horrible or disgusting. For me, his decomposition released forces that until then were bound, and that entered my bloodstream like waves of ether.

If you were not here, Christopher, I would have to keep on returning until 'Providence' should arrange – if that is the word – that I myself had the same aptitude as you: to be the crown of the tree instead of a branch.

In the hour of my death you, my son, will inherit the last cells of my physical form, the ones I have not been able to perfect, and it will be up to you to transmute them, to spiritualise them, and with them our whole line.

It could not happen to myself and our forefathers that we 'dissolved ourselves with the corpse', for the lady that rules in the realm of decay did not hate us as much as she hates you. Only those whom the Medusa hates and fears at the same time, as she hates and fears you, can succeed; she herself it is who brings about what she would prevent. When the hour is come, she will fall upon you with such boundless fury, in order to burn up every atom in you, that she will destroy her own image inside

134

you at the same time and will thus bring about that which man can never do of his own accord: she will kill a part of herself and bring you your eternal life. She will become the scorpion that stings itself. That will be the great reversal: no longer will life give birth to death, death will beget life!

I rejoice, my son, that you are called to be the crown of our family tree. You have turned cold in your young years, we all remained warm, in spite of age and decay. The sexual urge – whether it reveals itself, as in young people, or whether it is concealed, as in the old – is the root of death; to eradicate it is the vain striving of all ascetics. They are like Sisyphus, endlessly pushing his rock up the hill, to watch in despair as it rolls back down to the bottom. They want to achieve the magic state of coldness, without which it is impossible to go beyond the human condition, and so they avoid women. And yet it is woman alone that can bring them help. The female principle, that is separate from man here on earth, must enter them, must fuse with them, only then will fleshly longing be stilled. Only when the two poles coincide is the marriage complete, the ring closed, then the coldness is there, the coldness which is self-sufficient, the magic coldness which shatters the laws of the earth, which is no longer the opposite of warmth, which is beyond frost and heat, and from which pours forth everything that the power of the spirit can create, as if from nothing.

The sexual urge is the yoke on the triumphal carriage of the Medusa to which we are harnessed.

We of the older generations all married, but we were never 'wed'; you have never married, but you are the only one who is 'wed'. That is why you have turned cold, while we had to stay warm.

You understand what I mean, Christopher?"

I leaped to my feet and grasped my father's hand in both my hands. His eyes were shining, and that told me *he knew*.

The day of the Assumption of the Blessed Virgin arrived, the one on which, thirty-two years previously, I had been found as

a new-born child by the church door. Once more, as in my fever after the boat-trip with Ophelia, I heard the doors in the house open and close, and when I listened, I recognised my father's footsteps coming up the stairs and going into his room.

The smell of candlewax and smouldering bay leaves came into my room.

A good hour must have passed, then his voice softly called my name. Filled with a strange unease, I hurried to his room and saw by the sharp lines cutting deep into his cheeks and the pale colour of his face that his hour of death was at hand. He was standing up straight, but with his back against the wall, so as not to fall. His appearance was so strange, that for a moment I thought it was someone else standing before me. He was dressed in a long coat reaching down to the ground; a naked sword hung from a golden chain round his hips. I guessed he must have brought both from the lower stories of the house.

The table was covered with snow-white linen, but all that was on it were a few silver candlesticks, already lit, and an incense burner.

I saw that he was swaying and fighting to control the death-rattle; I was about to rush over to support him, but he held out his arms and waved my assistance away. "Can you hear them coming, Christopher?"

I listened, but everything was deathly quiet.

"Can you see the door opening, Christopher?"

I looked, but to my eyes it remained closed.

Again he looked as if he was about to collapse, but once more he drew himself up and a radiance shone in his eyes such as I had never seen in them before.

"Christopher!" he suddenly called to me in stentorian tones, which chilled me to the marrow. "Christopher, my mission is at an end. I have brought you up and watched over you, as was my duty. Come to me, I must give you the sign."

He took me by the hand and entwined his fingers in mine in a strange clasp. "This is the way", he went on softly, and I could hear that he was having difficulty breathing again, "that the

links in the great invisible chain are coupled. Without it, there is little you can do, but if you are joined to it, then there is nothing can resist you, for the powers of our Order will help you, even in the farthest corners of the universe. Listen to me: Be suspicious of all figures that come to meet you in the realm of magic. The powers of darkness are well able to feign any shape, even that of our Master; they can even imitate – in physical terms – the handclasp that I showed you, in order to lead you astray, but what they cannot do is remain invisible at the same time. The moment they were to attempt to enter our chain as invisible beings, they would dissolve into atoms!" He repeated the handclasp. "Remember this clasp well. If an apparition from the other world approaches you, and even if you should believe it is I, always insist on clasping hands. The world of magic is full of dangers."

His last words turned into a death-rattle, his eyes became veiled and his chin slumped down onto this chest. Then his breathing suddenly stopped. I took him in my arms, carefully carried him to his bed and kept watch over his dead body, until the sun came, his right hand in mine, the fingers intertwined in the clasp he had taught me.

On the table I found a message, which said:

"Have my body buried in my official robes, together with the sword, alongside my beloved wife. The Chaplain is to read a mass for me. Not for my sake, for I am alive, but to reassure him. He was a loyal, considerate friend."

I took the sword and looked at it for a long time. It was made out of the reddish mineral called haematite – the name means bloodstone – such as you often find in signet rings. It appeared to be of far-eastern workmanship and very ancient.

The dull, red hilt had very cunningly been made in the form of a human body. The arms were half outstretched to form the guard, the head was the pommel. The features of its face were unmistakably Mongolian and were those of a very old man with a long, sparse beard, such as you see on the pictures of Chinese

saints. On his head he wore a strangely shaped hat with earflaps. The legs were only indicated by engraving and merged into the sharp and shining blade. The whole was of a single piece, either cast or forged.

As I held it in my hand I had an indescribably strange sensation: it felt as if streams of life flowed out from it. Filled with awe, I placed it beside my dead father again.

Perhaps it is one of those swords, I told myself, of which legend says that they were once people.

Chapter 13

Hail, Holy Queen, Mother of Mercy

Once more months have passed.

The evil rumours about me have long since gone silent; the townsfolk probably think me a stranger, they hardly pay any attention to me, so long have I lived a hermit's life with my father, up there beneath the roof, far from any contact with them.

When I think back to that time, I find it impossible to believe that I did indeed mature from a youth into a man within those four walls and completely shut off from the world outside. Certain indications – for example the fact that I must have bought new clothes, shoes and suchlike things somewhere in the town – suggest that at that time my inner insensibility must have been so profound that everyday occurrences made no impression at all on my consciousness.

When, on the morning after my father's death, I went out into the street – for the first time in years, as far as I was aware – to make the necessary arrangements for his funeral, I was astonished at how much everything had changed. There was a wrought-iron gate across the entrance to our garden; through the bars I could see a large elder tree where I had once planted the branch. The seat had disappeared and in its place, on a marble plinth, stood a gilded statue of the Mother of God, bestrewn with wreaths and flowers. I could not think of the reason for this change, but to me it seemed like a holy miracle that the spot where my Ophelia was buried should now bear a statue of Mary.

When, later on, I met the Chaplain, I hardly recognised him, so old he seemed to have become. My father had visited him occasionally and brought greetings from him, but I had not seen him for years. He, too, was very surprised when he saw me, stared at me in bewilderment and refused to believe it was me.

"The old Baron asked me not to come to his house", he explained. "He said it was necessary for you to remain alone for a certain number of years. Although I could not understand his request, I respected it."

I felt like someone returning to the town of their birth after a very, very long absence. I met grown-ups whom I had known as children; I saw serious faces which had once been wreathed in youthful smiles; girls in the springtime of life had become harassed wives.

I cannot say that the feeling of being frozen numb inside left me at that time, it was just that something extra had been added, even if only a thin deposit, which allowed me once again to see the world around with more of a human eye. I assumed it was a breath of the animal life-force which had come to me as a legacy from my father.

As if he had an instinctive sense of this influence, the Chaplain developed a great affection for me and often came to visit me in the evening. "Whenever I am close to you", he said, "I feel as if my old friend were sitting before me."

As occasion presented itself, he told me the details of what had happened in the town during those years. It is part of that period that I now want to recall from oblivion:

"Do you remember, Christopher, that once when you were a little boy you told me the White Dominican had heard your confession? At the time I wasn't sure whether your imagination wasn't playing tricks on you, for what you told me seemed beyond belief. For a long time I wavered between doubt and the assumption that it might be some kind of demonic spirit or, if that sounds better to you, some kind of possession. Today, of course, when such unheard-of things are happening, there is only one explanation for me: a time of miracles is approaching, here in our town."

"What are all these things that have been happening?" I asked. "As you know, I have spent half a lifetime cut off from the world."

The Chaplain thought for a while. "It is best if I tell you about

the most recent period first, otherwise I wouldn't know where to begin. Well, it all started when more and more people claimed that at the time of the new moon they had seen with their own eyes the white shadow that our church is, according to legend, supposed to cast. I spoke out against the rumour wherever possible, until I myself – yes, I myself! – witnessed the phenomenon! And then ... it always moves me deeply when I talk about this ... but enough of that: I saw the 'Dominican' himself. Do not ask me to describe it; for me it is the most sacred experience imaginable.

"Do you think the Dominican is a man who possesses special powers, or do you believe, Father, that he is a kind ... of ghostly apparition?"

The Chaplain hesitated. "To be perfectly frank, I do not know. He appeared to me in the robes of a pope ... I believe, yes, I firmly believe I was seeing into the future, that I had a vision of the great pope to come who will be called "flos florum". Please do not ask me any more. Later there was talk that Mutschelknaus the carpenter had gone out of his mind with grief because his daughter had disappeared without trace. I followed the matter up and went to comfort him. But – he comforted me! I soon realised I was dealing with one of the blest. Today everyone knows that he can work miracles."

"Mutschelknaus can work miracles?!" I asked in astonishment.

"Yes. Didn't you know that our little town is well on the way to becoming a place of pilgrimage!" exclaimed the Chaplain in wonderment. "Goodness me, have you been sleeping all this time, like the monk of Heisterbach? Haven't you seen the statue of the Mother of God in the garden below?"

"Yes, I do know that", I admitted, "but what is the reason for it? Up to now I have not noticed many people making a pilgrimage to it."

"The reason for that", the Chaplain explained, "is that at the moment old Mutschelknaus is wandering about the countryside healing people by the laying on of hands. The people are fol-

lowing him in hordes. That is why the town is almost deserted just now. He is coming back tomorrow for Lady Day."

"Has he never told you that he attends spiritualist séances?" I asked cautiously.

"It was only right at the beginning that he was a spiritualist, now he keeps well away from them. I think it was a transitional stage for him. It certainly is true, unfortunately, that the sect has spread enormously. 'Unfortunately' I say, and I have to say it, for how could the teachings of these people be reconciled with those of the church? On the other hand I do ask myself which is better, the plague of materialism which has seized humanity, or this fanatical faith that has shot up all of a sudden and is threatening to consume everything else? We really are stuck between Scylla and Charybdis." The Chaplain gave me a questioning look and seemed to be expecting me to answer; I remained silent, my thoughts had returned to the head of the Medusa.

"One day", he went on, "they called me from the church. 'Old Mutschelknaus is going through the streets, he has raised a man from the dead', they were all crying excitedly. It was a most strange happening. The hearse was being driven through the town when the old man had ordered the driver to stop. "Bring out the coffin!" he had commanded in a loud voice. As if they were hypnotised, the people obeyed without hesitation. Then he himself unscrewed the coffin-lid. In it was the corpse of the cripple, you will remember him, he always used to hobble along on his crutches in front of wedding processions. The old man bent over him and said, using the words of Jesus, 'Stand up and walk.' And ... and ...", the Chaplain was sobbing with emotion, "and the cripple woke from the sleep of death. Later I asked Mutschelknaus how it all came about. I have to tell you, Christopher, that it is almost impossible to get anything out of him; he is almost permanently in an ecstatic state, which is getting worse by the month. Nowadays he gives no answer at all to questions; then, at least, I managed to get a little out of him.

"The Mother of God appeared to me", he said, when I questioned him. "She rose from the earth in front of the seat in the

garden where the elder tree grows."

And when I pressed him to tell me what she looked like, he said, with a blissful smile, "Just like my Ophelia."

"What gave you the idea of stopping the hearse, my dear Mutschelknaus?" I went on. "Was it the Mother of God that ordered you to?"

"No, I knew that the cripple only looked dead, but wasn't really."

"How could you know that, not even the doctor realised?"

"I knew because I was almost buried alive myself", was the old man's strange reply. I could never make him see how illogical his explanation was. "Something you have experienced in your own body, you can recognise in others. It was a great mercy the Virgin showed me that they tried to have me buried alive when I was a child, otherwise I would never have been able to know that the cripple wasn't really dead." He repeated this in all possible variations, but although I tried to pin him down, he never got to the heart of the matter; we kept talking at cross purposes."

"And what happened to the cripple?" I asked the Chaplain. "Is he still alive?"

"No, that is the strange thing about it, he met his death in that very same hour. Because of all the noise from the crowd, a cart-horse shied and bolted across the market-place, knocking the cripple to the ground; the wheel broke his spine."

The Chaplain told me of many more remarkable cures performed by the old carpenter. In vivid words he described how the news of the appearance of the Mother of God had spread throughout the region, in spite of the mockery and scorn of those who called themselves enlightened; he described how many pious legends had arisen and how, finally, the elder tree in the garden had become the focal point of all the miracles. Hundreds who had touched it had been made well, thousands who had lost their faith had repented and returned to the fold.

By this time my mind was only half on what the Chaplain was telling me. I seemed to see, as through a magnifying glass, the

tiny, yet so powerful gears of spiritual history mesh. The cripple, in the same hour brought back to life and then delivered up to death: could there be a more obvious sign that a blind, equally deformed and yet astonishingly effective, invisible power was at work? And then the old carpenter's explanation! On the surface childish and illogical, but below the surface opening up depths of wisdom. And how miraculously simple was the way in which the old man had escaped the snares of the Medusa, the delusions of spiritualism: Ophelia, the idealised image to which he was attached with all the power of his soul, had turned into a saint, full of grace. She was a part of his self that had separated from him and was rewarding him a thousand times over for all the sacrifices he had made for her, was performing miracles, bringing enlightenment to him, drawing him up to heaven and revealing herself to him as the divinity. The soul its own reward! Purity of heart: a guide to a state beyond the human condition, a channel for all healing power. And like a spiritual contagion, his faith, which has taken on living form, has even infected the mute creatures of the vegetable world: the elder tree makes the sick well again. There are, however, still certain puzzles, the solution to which I can only vaguely guess at. Why is it that the place where this power has its source is the one where Ophelia's bones have been laid to rest, rather than any other? Why is it that this tree, which I planted with the inner sense that in so doing I was enriching the world of life, why is that particular one chosen to be a focal point of supernatural events? It was for me beyond doubt that Ophelia's metamorphosis into the Mother of God must have taken place according to similar magic laws as happened at the spiritualist séance. But then what has happened to the deadly influence of the head of the Medusa, I asked myself? In a philosophical sense, were Satan and God, as the ultimate truths and paradoxes, the same, destroyer and creator one and the same?

"From your point of view as a Catholic priest, Father, do you think it is possible for the Devil to assume the form of a sacred figure, say Jesus or the Virgin Mary?"

For a moment the Chaplain stared at me, then he clapped his hands over his ears and cried, "Stop, Christopher, stop! It's your father's spirit that prompted you to ask that question. Please leave my faith in peace. I'm too old for such shocks. When I come to die, I want to die with my belief in the divine origin of the miracles I have seen and marvelled at intact. No, I say, no, and no again. However many forms the Devil can assume, he must stop at the Blessed Virgin and her Son, who is also the Son of God!"

I nodded and said nothing. I kept my mouth shut tight, as I did during the séance when in my mind I heard the mocking words of the head of the Medusa, "Why don't you tell them everything you know?!"

What is needed for the future is a great leader who will have complete mastery over words and use them to reveal the truth without killing those who hear them. Otherwise all religion will be nothing more than a half-dead cripple. At least that is what I feel.

I was awakened early next morning by the sound of the bells ringing from the towers, and I could hear a soft chant with a barely subdued undertone of wild excitement.

"Hail Mary, Mother of Grace, blessed art thou among women."

An eerie rumbling went through the walls of the house, as if the stones had come alive and were joining in the singing in their own way. 'Years ago it was the hum of the lathe that filled the alleyway; now the torment of labour is silent and the hymn to the Mother of God is rising from the ground as a kind of echo', was the thought that passed through my mind as I went down the stairs.

I stood in the house doorway, and along the narrow street, with Mutschelknaus at the head, came a procession of people in their Sunday best, thronging together and carrying mountains of flowers.

"Holy Mary, Mother of God, pray for us."

"Hail, holy Queen, Mother of Mercy."

The old man went barefooted and bareheaded, his dress was the habit of an itinerant monk; it had once been white, but now was threadbare and covered in patches. He walked unsteadily, feeling his way like a blind old man. He glanced at me in passing; for a brief moment his eye rested on my face, but there was no trace of recognition or memory to be seen in it. His pupils were fixed in parallel axes, as if he was looking through me and the walls into another world.

More drawn by an invisible power than under his own impulse, or so it seemed to me, he made his slow way to the wrought-iron gate at the entrance to the garden, opened it and went up to the statue of the Virgin. I joined the crowd shuffling along a respectful distance behind; they seemed to be in awe of him and stopped at the gate. The singing grew softer and softer, but the undertone of excitement was becoming more intense by the minute. Soon it was a wordless, vibration of notes; there was an indescribable tension in the air.

I had jumped up onto a ledge projecting from the wall, from which I could see everything clearly. For a long time the old man stood motionless before the statue. It was a disquieting sight; I began to wonder which of the two would come alive first. I was seized by a dull fear, similar to the one I had felt at the spiritualist séance, and once more I heard Ophelia's voice in my heart, "Be on your guard!"

Immediately after that I saw the old man's white beard begin to quiver, and from the twitching of his lips I guessed that he was speaking to the statue. A deathly hush suddenly came over the crowd behind me, even the soft singing of those at the back stopped, as if a sign had been given.

The only sound that was left was a soft, rhythmical and repetitive jingling. I looked around to see where it was coming from: timidly squeezing into an alcove in the wall, as if he were hiding, was a fat old man with a laurel wreath on his bald head; with one hand he was half covering his face, while the other was stretched out, holding a tin box. Beside him in a black silk dress,

with such thick make-up on as to be almost unrecognisable, was Frau Aglaia.

That toper's nose, shapeless and blue, those eyes, hardly visible behind the rolls of fat: there was no doubt about it, it was Herr Paris, the actor. He was collecting money from the pilgrims and Frau Mutschelknaus was helping him. I saw her quickly lean forward from time to time and cast an anxious glance at her husband, as if she was afraid he might see her there. Then she would whisper something to the people around her, who would mechanically feel in their pockets and, without taking their eyes off the statue of the Mother of God, drop a couple of coins in the tin.

A furious rage took hold of me, and I glared at the actor; immediately our eyes met and I saw his chin drop and his face turn ashen grey. He almost let the collecting box fall with shock. Filled with disgust, I turned away.

"She is moving! She is speaking! Blessed Virgin, pray for us! She is talking to him! There! See, she is bowing her head!" Suddenly a hoarse muttering, scarcely comprehensible, as if it were muffled by shivers of abrupt horror, ran through the crowd from one set of pale lips to another. "There! There! And again!"

I felt that any moment one single, piercing cry must erupt from the many hundred living lips and release the dreadful tension, but it was as if all were paralysed. Only here and there I heard an occasional confused, babbling "Pray for us". I was afraid a riot was about to break out, but instead the crowd just slumped somewhat: they wanted to fall to their knees but were too tightly packed. Many had closed their eyes, as if they had fainted, but they could not fall to the ground, they were wedged in. They were so deathly pale, they looked like corpses standing upright among the living, waiting for a miracle to wake them from the dead.

The atmosphere had such a kind of stifling magnetism that when I breathed in it felt as if I were being throttled by invisible hands. My whole body was shaking, as if the flesh were trying

to free itself from the bones. So as not to fall down, I clung to the window-ledge.

I could clearly see the old man's lips in rapid movement as he talked. His emaciated features, bathed in the rays of the rising sun, shone with an almost youthful glow.

Then he suddenly paused, as if he had heard someone call out to him. His mouth wide open as he strained to hear and his eyes fixed on the statue, he nodded with a beatific expression on his face, quickly gave a soft reply, then listened again, raising his arms now and again in joyful excitement.

Every time he thrust his head forward to listen, a throaty whisper, more a wheezing than a murmuring, went through the crowd – "There! There! She's moving! There! Now! She nodded!" – but no one pushed forward, rather they drew back in horror, staggered back as if hit by a gust of wind.

I scrutinised the expression on the old man's face as closely as I could; I was trying to read his lips to see what he was saying. Secretly I was hoping – I had no idea why – to hear or read the name Ophelia, but all I could make out were long, incomprehensible sentences followed by something like "Mary".

There! It was as if I had been struck by lightning: the statue had smiled and bowed its head! Not only the statue, its shadow on the light-coloured sand had also moved!

In vain I told myself it was an hallucination, my eye must have involuntarily transferred the old man's movements to the statue, making it look as if the statue were moving. I looked away, determined to regain control of my senses, and looked back again: the statue was speaking! Was bending down to the old man! There was no longer any doubt about it.

"Be on your guard!" What use was it that I dwelled on the inner warning with all my strength?! What use was the clear sense of a vague yet infinitely dear something within my heart, what use the knowledge that it was the eternal presence of my beloved trying to resist, desperately trying to take on tangible form so that she could stand before me with outstretched arms and protect me?! I was slowly being drawn into a vortex of

magnetism, stronger than my will-power. All the religiosity, all the piety which I had absorbed in my childhood and which, until now, had lain dormant in my ancestral blood, broke loose, engulfing cell after cell. A spiritual storm in my body began to hammer at the back of my knees, repeating the order, "I want you to kneel down and worship me."

'It is the head of the Medusa', I told myself, but at the same time I felt that reason was futile. I took refuge in my last line of defence: 'Do not resist evil.' I gave up resisting and let myself sink into an abyss of complete acquiescence. I became so weak that even my body was affected by it; my hands let go their hold and I tumbled down onto the heads and shoulders of the crowd below.

I have no idea how I managed to make my way back to the door of my house. The details of such strange events often do not penetrate our perception, or pass through without leaving any trace in the memory. I must have crawled like a caterpillar over the heads of the tightly packed throng of pilgrims! All I know is that I found myself back in the arch of the doorway, incapable of moving forwards or back; but the statue was removed from my view and I from its magic influence. The magnetic current emanating from the crowd flowed past me.

"To the church!" From the garden echoed a cry in which I was sure I recognised the voice of the old carpenter. "To the church!"

"To the church, to the church." The call rebounded from mouth to mouth, "To the church. It is Mary's command", and swelled into a many-voiced roar that finally released the tension.

The spell was broken. Slowly, step by step like some gigantic fabulous beast with a hundred feet that was freeing its head from a noose, the crowd backed out of the alley. The last ones had surrounded the old man and, as they pushed past me, they were tearing off pieces of his robe, until he was almost naked, kissing them like sacred relics.

When the alleyway was once more deserted, I went through

149

the thick covering of trampled flowers to the elder tree. I wanted to touch again the spot where the bones of my beloved were laid to rest. I had a clear feeling that it would be the last time. "Can it be that I will never see you again, Ophelia? Not even one more time?" I poured out my entreaty into my heart. "I long to see your face again, just one more time."

A current of air carried the sound of the chant from the town, "Hail, holy Queen, Mother of Mercy."

Involuntarily, I raised my head.

The statue before me was bathed in a light of unutterable brightness. For the tiniest fraction of a second, so short that a heartbeat seemed a lifetime by comparison, it was transformed into Ophelia and smiled at me; then once more it was rigid and motionless, the golden face of the Madonna gleaming in the sun.

I had had a brief vision of the eternal present, which, for us mortals, is nothing but an empty, unfathomable word.

Chapter 14

The Resurrection of the Sword

It was an unforgettable experience when, one day, I started to go through my inheritance from my father and our forebears. I inspected one storey after the other; I felt as if I were climbing down the centuries until I was back in the Middle Ages.

Above elaborately inlaid pieces of furniture, the drawers full of lace, were blind mirrors in shimmering gold frames from which my image looked back at me like a greenish, milky ghost; there were darkened portraits of men and women in antiquated dress, the look changing according to the period, but always with a certain family likeness in the faces, which sometimes lessened, the hair changing from blond to brown, to reappear in its true lineaments, as if the blood-line had suddenly decided to revert to type.

I found gold boxes decorated with precious stones, some still containing traces of snuff, as if they had still been in use only yesterday; mother-of-pearl fans; bizarrely shaped high-heeled shoes of threadbare silk which, as I placed them beside each other, called to mind youthful female figures, the mothers and wives of our ancestors; sticks with yellowed ivory carvings; rings with our coat of arms, some tiny, as if made for a child's finger, and others so large that giants must have worn them; distaffs on which the tow had become so thin with age that it disintegrated when you breathed on it.

In some rooms, the dust was so deep that I waded ankle-deep through it and it made huge ridges when I opened the doors; in my footmarks floral ornaments and animal faces appeared as my steps laid bare the patterns of old carpets.

I was so enthralled by the sight of all these objects that I spent weeks examining them and sometimes lost all sense that there were other people than I living on this earth.

Once, as a boy, I had been taken on a school trip to the town

151

museum, and I can remember the weariness that befell us as we looked at all the antique objects that meant nothing to us. How different it was here! Every object I picked up had a story to tell, they all exuded a particular sense of life: they were steeped in the history of my own family and filled me with a strange mixture of past and present. People whose bones were now rotting in the grave had breathed this air; forebears, whose life I bore within me, had lived in these rooms, had begun their existence as snivelling infants and ended it in the rattle of death throes, had loved and mourned, rejoiced and sighed, had cherished things which now stood where they had been abandoned and which filled with secret whisperings when I picked them up.

There was a glazed corner cupboard containing medallions in red velvet cases, golden ones with the profiles of knights, still bright with a lively glow, and silver ones that had gone black as if they had died, all laid out in rows and each with a ticket on which the writing was faded and illegible. They transmitted a decrepit and yet passionate craving: 'Collect us, collect us, we must become complete'. Characteristics which I had never possessed fluttered up to me, caressed me and begged, 'Take us in, we will make you happy.'

An old armchair with wonderfully carved armrests, apparently the personification of dignity and repose, lured me to dream in its arms with the promise of tales from the old days; then, when I had entrusted myself to it, I was smothered by a wordless, senile torment, as if it were the grey spirit of care itself in whose lap I was sitting, my legs grew heavy and stiff, as if a cripple had been bound there for a hundred years and was trying to escape by turning me into his likeness.

The farther I penetrated into the lower rooms, the darker, grimmer, plainer became the surroundings: rough deal tables; a stove instead of elegant fireplaces; whitewashed walls; pewter plates; a rusty chain-mail gauntlet; earthenware jugs. Then came a chamber with a barred window; parchment volumes scattered about, gnawed by rats; clay retorts such as alchemists used; an iron candlestick; phials in which the liquid had solid-

ified: the whole room was filled with the dismal aura of a life of dashed hopes.

The cellar, in which, according to the chronicle, our Founding Father, the lamplighter Christophorus Jöcher, was supposed to have lived, was blocked by a heavy lead door. It was impossible to break it open.

When I had completed the investigation of our house and returned, as if after a long journey into the realm of the past, to my living room, I had the feeling I was charged to the fingertips with magnetic influences. The forgotten atmosphere from down below accompanied me like a horde of ghosts whose dungeon door had been unlocked, releasing them into the open; desires that my ancestors' lives had left unfulfilled had been dragged out into the light of day and had woken up, filling me with unrest and bombarding me with requests, "Do this, do that; this is still undone, that only half finished; I cannot sleep until you have completed it in my stead." A voice whispered to me, "Go back down to the retorts, I'll tell you how to make gold and the philosopher's stone; I know how to do it now, I couldn't manage it before, I died too soon." Then I heard soft, tearful words, "Tell my husband I always loved him, in spite of everything; he doesn't believe it and he can't hear me now I'm dead; he'll understand you." "Vengeance! Seek out his brood. Slay them. I'll tell you where they are. Remember me! Yours is the inheritance, yours is the duty of the blood feud!" another hissed with breath that scorched my ear, and I felt as if I could hear the rattle of the gauntlet. "Go out into the world! Enjoy life! Through your eyes I want to see the earth again", the cripple in the armchair called out, trying to ensnare me.

When I drive them out of my brain, these spectres, they seem to turn into unconscious scraps of electric life fluttering about that is absorbed by the objects: there is an eerie cracking noise in the cupboards; a notebook lying on the shelf rustles; the floorboards creak, as if under the weight of a foot; a pair of scissors falls off the table and sticks with one point in the floor, imitating a dancer balancing on one toe.

I pace up and down, full of unease. 'It must be the legacy of the dead', I feel. I light the lamp, for night is falling and the darkness makes my senses too sharp. The spectres are like bats; 'Surely the light will drive them away; I won't have them going on raiding my consciousness.'

I have silenced the desires of the departed, but I cannot get the restlessness of the spectral legacy out of my nerves.

To take my mind off it, I start rummaging around in a cupboard. I come across a toy my father once gave me for Christmas: a box with a glass lid and base with little figures formed from the pith of elder branches in it: a man, a woman and a snake. When you rub the glass with a leather pad they become electric and join, separate, hop about, stick to the top or bottom, and the snake wriggles and jiggles with joy. 'Those figures in there think they're alive, too', I muse, 'and yet it's only the one, universal force that makes them move.' However, it does not occur to me to apply this example to myself. I am suddenly overcome with a desire for action towards which I feel no suspicion: the vital urge of the departed is approaching me behind another mask.

'Deeds, deeds, deeds, that's what is needed', I feel. 'Yes, that's it. It's not the selfish desires of our forefathers that I should be carrying out', I try to convince myself, 'no, it's something much greater I should be aiming for.'

It is like seeds that were slumbering inside me, now they are sprouting, shoot after shoot: 'You must go out into the world, and do great deeds for the sake of mankind of which you are, after all, a part. Be a sword in the general battle against the head of the Medusa.'

The atmosphere in the room is unbearably sultry. I fling open the window. The sky has turned into a leaden roof, an impenetrable, blackish grey. In the distance there is a flicker of lightning on the horizon. Thank God, a storm is coming. For months there has not been a drop of rain, the grass is all withered, during the day the woods quiver in the shimmering haze of the parched earth.

I go over to the table to write. What? To whom? I do not know. To the Chaplain, perhaps, since I am thinking of starting out on my travels to see the world? I cut a quill and set pen to paper, but then I am overcome with tiredness. My head sinks onto my arm and I fall asleep.

The table-top is like a sounding board, amplifying the beat of my pulse; it turns into a hammering, and I imagine I am hacking open the metal door in the cellar with an axe. As it falls from the rusty hinges, I see an old man come out. At that moment I wake up.

Am I really awake? There is the old man here in the room, looking at me with his dull, aged eyes. The fact that I still have the quill in my hand, proves that I am not dreaming and that I am in my right mind.

'I must have seen this peculiar stranger somewhere', I think to myself. 'Why is he wearing fur ear-muffs at this time of the year?'

"I knocked at the door three times", the old man says. "When no one answered, I came in."

"Who are you? What are you called?" I ask in bewilderment.

"I have come on behalf of the Order."

For a moment I wonder whether it is a ghost I see before me. The ancient face with the sparse, oddly shaped beard does not go with those muscular, workman's hands. If it were a picture I was looking at, I would have said it was badly drawn. There is something wrong with the proportions. His right thumb is misshapen, too; that also seems strangely familiar to me.

Secretly, I touch the man's sleeve, to prove that it is not my senses that are playing tricks on me, and then turn the movement into a gesture asking him to sit down.

The old man ignores it and remains standing. "We have received news that your father has died. He was one of us. According to the rules of the Order, you, as his son by birth, have the right to demand that you be received into it. I have come to ask you, do you intend to make use of that right?'

"To belong to the same community as my father would be my

greatest joy, but I do not know what purpose it serves, what its goal is. Can you tell me something about it?"

The old man's dull eyes wander over my face. "Did your father never talk to you about it?"

"No. Only in vague hints. I presume from the fact that he put a kind of habit on in the hour before his death that he must have belonged to some secret society, but that is all that I know."

"I will tell you then: since time immemorial there has been a circle of men on earth which guides the destiny of mankind. Without them chaos would have descended upon the world long ago. All the great leaders of the nations have been blind instruments in our hands, that is, if they were not members of our Order. Our goal is to remove the differences between rich and poor, between master and servant, the initiated and the ignorant, rulers and oppressed, to make this vale of tears that we call the earth into a paradise, a land in which the word 'sorrow' is unknown. The burden under which mankind is groaning is the cross of individuality. The world-soul has disintegrated into separate beings, and that is the source of all disorder. Our determination is to turn the multiplicity back into unity.

The noblest minds have put themselves at our service and the time of harvest is at hand! Every man is to be his own priest. The masses are ready to shake off the yoke of the Church. Beauty is the only god to which mankind will pray in future. But there is still need of men of vigour to set it on high. That is why we fathers of the Order have sent out currents of thought into the world which will sweep like wildfire through the minds of men and burn out the madness of the doctrine of individualism. The war of everyone for everyone! Creating a garden from the wilderness is the task we have set ourselves. Can you not feel how everything within you is crying out for action? Why are you sitting here dreaming? Arise and save your brothers!"

I am seized by a wild eagerness. "What should I do?" I cry. "Command me! Tell me what I should do! I will sacrifice my life for mankind, if it must be! What conditions must I fulfil to

join the Order?"

"Blind obedience! Renunciation of all personal desire! To work for the whole and no longer for yourself! That is the way out of the desert of multiplicity into the promised land of unity."

"And how will I know what it is I have to do?' I ask, suddenly filled with doubts. "I am to be a leader, what shall my teaching be?"

"When you teach, you learn. Do not ask, What shall I say? If God gives you an office, he will also give you understanding. Go forth and speak. The thoughts will come, do not worry. Are you ready to take the oath of obedience?"

"I am ready."

"Then put your left hand to the earth and repeat after me the words I shall say."

In a daze, I am bending down to obey when I am suddenly seized with suspicion. I hesitate, look up, and a memory twitches at my mind: I have seen the face of the old man standing before me, carved out of haematite on the pommel of a sword; and the misshapen thumb belongs to the hand of the tramp who fell down dead in the market-place when he saw me, all those years ago.

I feel a chill of horror, but now I know what I have to do. I jump up and shout at the old man, "Give me the sign!" and hold out my right hand to him for the 'clasp' my father showed me.

But standing before me is no living man any more, but a thing of limbs loosely attached to a trunk, like someone who has been broken on the wheel. The head is hovering above, separated from the neck by a gap the width of a finger; the lips are still quivering from the expiry of breath. A gruesome jumble of flesh and bone.

With a shudder, I covered my eyes with my hands. When I looked up, the phantom had disappeared, but hanging freely in the air was a shining ring, in which hovered the face of the old man with the ear-muffs in fine, transparent outline like pale blue mist. This time it was the voice of the Founding Father that came from its lips, "What you have seen was debris, spars from

wrecked ships that had been drifting on the ocean of the past. In order to deceive you, the spectral inhabitants of the abyss created the image of our Master as a phantasm formed from the soulless remains of drowned men, from forgotten impressions in your own mind; with your own tongue they were speaking to you empty, hollow words of temptation to lure you, like will o' the wisps, into the deadly swamps of aimless activity in which thousands before you, and greater ones, have sunk without trace. 'Renunciation' is the name they give to the phosphorescence with which they trick their victims; there was rejoicing in hell when they lit it for the first person to trust them. What they want to destroy is the noblest possession a person can acquire, our eternal consciousness as an individual. Their teaching is death and destruction, but they know the power of truth, so all the words they choose are true, but every sentence they form from them is a pit of lies.

Whenever vanity and the lust for power reside in a person's heart, there they are on hand to fan these dull sparks into a bright flame, so that the individual concerned imagines he is afire with selfless love for his fellows and goes forth to preach without being called, becomes a blind leader and falls into the pit with the halt and the lame.

They well know that the heart of man is evil, from his earliest youth, and that love cannot reside within it, unless it is a present from above.

They repeat the command, "Love one another", until it is quite worn away. The one who first spoke these words gave those who heard them a spiritual gift, but *they* spit the words into people's ears like poison, causing disaster and despair, murder, carnage and devastation. They imitate truth as a scarecrow imitates the wayside crucifix.

Whenever they see a crystal that is threatening to form a symmetrical shape – an image of God – they do all they can to shatter it. No doctrine from the East is too fine but they will coarsen it, bring it down to earth, surround it and perforate it until it says the opposite of what was intended. "From the East

comes light", they say, and secretly mean pestilence.

The only goal which is worth pursuing – the cultivation of one's own self – they call egoism. They try to introduce into the minds of erring mortals the idea that they must save the world, without giving them any idea how to do it; they mask greed with the name of 'duty' and envy with that of 'ambition'.

Their dream for the future is a world of splintering consciousness, obsessions everywhere. Through the mouths of the obsessed they preach the coming of the millennium, as did the prophets of old, but the fact that the millennial empire will not 'be of this world' until the earth is transformed and man is changed through the rebirth of the spirit, that they omit to mention; they give the lie to the anointed ones by pretending the time is ripe before it is.

If a messiah is expected, they pre-empt him; when one departs, they mock him. They say, "Be a leader", well knowing that only one who has been perfected can be a leader. They invert it to deceive people, saying, "Lead, and you shall be perfected."

It is said, if God gives you an office, he will also give you understanding.

But they whisper, "Take an office and God will give you understanding."

They know that life on earth is only meant to be a transitional state, so they cunningly tempt you by saying, "Make a paradise on earth", well knowing the vanity of such attempts.

They have released the shades from Hades and brought them to life with a daemonic force so that men will believe that the resurrection of the dead has come.

They have made a mask, formed after the face of our Master, a spectre which pops up here and there, now in the dreams of those with second sight, now as apparently corporeal figures appearing at spiritualist séances, now as the automatic drawings mediums produce. To those who enquire after its name, the ghost calls itself John King, to give rise to the belief it is John the Evangelist. For all those who, like you, are mature enough

to see the face in *truth*, they pre-empt it; they are preparing the ground so that they can sow the seed of doubt when, as now with you, the hour approaches when unwavering faith is needed.

You destroyed the mask when you demanded the 'clasp'. Now the true face will become the pommel of your magic sword, fashioned without joint from a single piece of 'blood-stone'. Anyone who receives such a sword will find that the words of the Psalm become reality, "Gird thy sword upon thy thigh, and ride thou for the sake of truth and to do justice to the afflicted and the needy; and thy right hand shall perform wondrous things."

Chapter 15

The Shirt of Nessus

Just as the cry of the eagle, piercing the air above the snowy mountain tops, dislodges a cornice which rolls down the slope and turns into an avalanche, uncovering the splendour of hidden sheets of ice, so the words of our Founding Father have dislodged a portion of my self within me. The words of the Psalm are drowned by a howling blast in my ear, the room vanishes before my eyes and I feel as if I am falling out into boundless space.

'Now, now I am going to smash against the ground!' But the fall seems never-ending. The depths suck me in at ever greater, ever more vertiginous speed, and I feel the blood shoot up my spine and break out of my skull in a radiant sheaf. I hear the cracking of my bones, then everything is over. I am standing on my feet and realise that it was an hallucination: a magnetic current ran through me from the soles of my feet to the crown of my head, giving me the feeling I was plunging into a bottomless pit.

Bewildered, I look around, surprised to see that nothing has changed, that the lamp on the table is still burning with an untroubled flame, for I feel as if I have been transformed, as if I had wings I could not use.

I realise that a new sense has opened up within me, and yet for a long time I cannot work out what it is and in what way I am different, until I slowly become aware of a round object I am holding in my hand. I look at it: there is nothing to see; I open my fingers: the thing disappears, though I hear nothing fall to the ground; I clench my fist and it is back again, cold, round as a ball, and hard.

I suddenly guess that it is the pommel of the sword. I feel for the blade; it is so sharp it cuts my skin.

Is the sword hovering in the air?

I take a step backwards from the spot where I am standing

and reach out to grasp it. This time my fingers close on smooth metal rings forming a chain round my hips, from which the sword hangs.

A sense of astonishment creeps over me which only disappears as it gradually becomes clear to me what has happened: my inner sense of touch, the sense that sleeps most soundly within mankind, has awoken. The thin partition separating earthly life from the world beyond has been broken.

Strange! So infinitesimally narrow is the threshold between the two realms, and yet no one raises their foot to cross it! The other reality borders on our skin, yet we do not feel it! Our imagination stops here, where it could create new land.

It is the longing for gods and the fear of being left alone with himself, to create a world of his own, which hinders man from unfolding the magic powers which slumber within him; he wants companions to accompany him, the power of nature to envelop him; he wants to feel love and hate, to do deeds and feel their effect. How could he do all this if he made himself creator of new things?

I feel the warmth of passion luring me on, 'You only need to stretch out your hand and you will touch the face of your beloved', but I shudder with horror at the thought that reality and imagination are the same. Staring me in the face is the awfulness of ultimate truth.

Even more dreadful than the possibility that I might have been touched by demons, or that I might be drifting out into the unbounded sea of madness and hallucination, is the realisation that there is no reality, neither here nor there, but that all is imagination.

I remember my father's anxious words, "Did you see the sun?" when I told him of my walk on the mountain. "Anyone who sees the sun will give up wandering; he will enter eternity."

"No, I want to remain a wanderer and see you again, father! I want to be united with Ophelia, and not with God! I want infinity and not eternity, I want the things that I have learnt to see and hear with my spiritual eyes and ears to become reality

for my feeling. I renounce becoming a god crowned with creative power; out of love for you I want to remain a created man; I want to share life equally with you."

As if to keep myself from the temptation to stretch out my arms in longing, I clasp the hilt of the sword tightly.

"I entrust myself to thy aid, Master. Be thou the creator of all that surrounds me."

So clearly does my exploring hand become aware of the face on the pommel, that I feel as if I can sense it deep within me, it is sight and touch at once, raising an altar to contain the holy of holies.

A mysterious power flows from it, entering objects and breathing life into them.

I know – as if I could hear it in words – that the lamp there on the table is the image of my earthly life, it illuminated the room of my solitude, now its flame is smoking: the oil is running out.

I feel an urge to be out in the open air, under the sky, when the hour of the great reunion comes.

There is a ladder leading up onto the flat roof, where I often secretly sat as a child to watch in amazement as the wind blew the clouds into faces and dragon shapes. I climb it and sit on the parapet.

The town below is immersed in darkness.

Image after image from my past life floats up and anxiously presses up against me, as if to say, 'Hold me fast, take me with you so that I might live in your memory and not die in oblivion.'

The lightning is flickering all round the horizon, a glowing, gigantic eye, peering here and there; and the houses and windows reflect the glare up onto me, their flares treacherously sending back the signal: 'There! There! There is the one you are looking for!'

A distant howling comes on the air, "All my servants you have killed, now I am coming myself." My mind is filled with the thought of the Mistress of Darkness and of what my father said about her hatred.

"The shirt of Nessus!" hisses a gust of wind, tearing at my clothes.

The thunder roars a deafening "Yes!"

'The shirt of Nessus?' I ponder. 'The shirt of Nessus?'

Then a deathly hush, an ominous pause; the storm and lightning are working out what to do next.

Suddenly from below comes the sound of the river, very loud, as if it were trying to warn me, "Come down to me and hide."

I can hear the horrified rustling of the trees, "The strangling grip of the wind-demon! The centaurs of the Medusa, the Wild Hunt! Keep your heads down, the rider with the scythe is coming!"

A quiet, exultant voice throbs within my heart, "I am waiting for you, beloved."

The clock in the church tower breaks out sobbing as it is hit by an unseen fist.

In the glare of a flash of lightning the crosses in the graveyard light up questioningly. "Yes, mother, I am coming!"

Somewhere a window is torn from its hinges and shatters on the cobbles with a piercing cry: the mortal anguish of objects that have been created by human hand.

Has the moon fallen out of the sky, is it wandering over the earth? A glowing white sphere makes its hesitant way through the air, swaying, sinking, rising, floating aimlessly, until, suddenly seized with a wild fury, it explodes with a clap of thunder. The earth quakes in uncontrollable terror.

More and more of the spheres arrive. One of them scours the bridge, rolling slowly, slyly over the planks, then circles round one beam, seizes it with a roar and smashes it into splinters.

"Ball-lightning!" I had read about it in one of my childhood books, thinking its mysterious motions a myth, and now here it is, in all its destructive reality! Blind beings, balls of electricity, bombs of the cosmic abyss, demon's heads without eyes, ears, mouths or noses, risen from the depths of the earth and the air, tornadoes whirling round a nucleus of hatred, without organs of

perception, but with a primitive consciousness that gropes around in search of victims for its destructive fury.

What terrible power they would possess if they had human shape! Is it my unspoken question that has attracted this glowing sphere that suddenly swings out of its orbit and flies towards me? But close to the balustrade it sheers off, glides towards a wall then sails in through an open window and out of another; then it stretches out and, with a crash of thunder, a tongue of fire blasts a shell-hole in the sand, making the house tremble and the dust spurt up to where I am sitting.

The flash, as blinding as a white sun, sears my eyes; for a second my body is illuminated with such incandescence that its image charges my eyelids and etches itself on my consciousness.

"Can you see me at last, Medusa?"

"Yes, I can see you, accursed mortal!" and a red sphere rises out of the earth. Half-blind, I can sense it is growing bigger and bigger. Now it is hovering over my head, a meteor of boundless fury.

I spread my arms wide: invisible hands grasp mine with the 'clasp' of the Order, uniting me with the invisible chain which stretches to infinity.

That which was corruptible in me has been consumed by fire, transformed by death into a flame of life.

Erect I stand in the purple robe of fire, girded about with the bloodstone sword.

Dissolved for ever with corpse and sword.